PICTURES FROM
A DRAWER

PICTURES FROM A DRAWER

PRISON AND THE ART OF PORTRAITURE

BRUCE JACKSON

Temple University Press
Philadelphia

Temple University Press
1601 North Broad Street
Philadelphia, PA 19122

www.temple.edu/tempress

Copyright © 2009 by Temple University
All rights reserved
Published 2009
Printed in China

Text design by Alex Bitterman

This book has been printed on acid-free paper for greater strength and longevity.

Library of Congress Cataloging-in-Publication Data

Jackson, Bruce, 1936–

Pictures from a drawer: Prison and the art of portraiture / Bruce Jackson.
 p. cm.
Includes bibliographical references.
ISBN 978-1-59213-948-4 (cloth : alk. paper)
ISBN 978-1-59213-949-1 (paper : alk. paper)
1. Prisoners—United States—Portraits. 2. Portrait photography—United States—History—20th century. I. Title.

TR681.P69J33 2009
779'.936560975—dc22

2008024250

2 4 6 8 9 7 5 3 1

For Cooter, and all the others who lived it.

At the sight of blackbirds
Flying in a green light,
Even the bawds of euphony
Would cry out sharply.

— Wallace Stevens
"Thirteen Ways of Looking at a Blackbird"

CONTENTS

1
PICTURES FROM A DRAWER

PHOTOGRAPHERS AND THEIR SUBJECTS

THREE ACTORS ARE involved in every portrait photograph: the sitter, the photographer, and, later, the looker. The first two are set forever the moment the shutter closes; the third has the potential of infinite variation. The looker knows exactly what the physical consequence of the portrait event looks like—it is literally the photograph on the page or in the frame or in hand—and knows equally well who the person is looking at the photograph. With rare exceptions,[1] the sitters know the portrait is being made and how they are to deport themselves for it: the same individual addresses the camera differently at a family gathering, at the driver's license bureau, in a police station, in a prison.[2] Excepting self-portraits, the photographer is invisible, a presence we can only infer.

1 One of the best-known exceptions is Walker Evans's 1938 portraits of passengers on the New York subway, published by the Museum of Modern Art in 1966 as *Many Are Called*. The photos were done on the sly. The camera settings were all the same, since the subway cars all had the same level of light and the lens-to-subject distance never changed because Evans sat on one side and took pictures of whoever was sitting on the bench opposite him. Evans used a 35mm Contax camera hidden beneath his coat. He released the shutter with a cable running down his sleeve.

2 In a review of the catalog for the 1977 San Francisco Museum of Modern Art exhibit *Police Pictures: The Photographs as Evidence*, Jeannene M. Przbylski wrote: "By now, everyone knows how to assume the pose. To submit to the mugshot convention is to internalize the protocols of discipline; it is to agree to act like you are already a corpse. Among other visitors, San Francisco's sheriff Mike Hennessey toured *Police Pictures*, remarking, 'That's another thing that hasn't changed. They always look like criminals in their mugshots.' But while the presumption that criminals look criminal predates the invention of photography, photography's particular ability to produce the criminal was a longer time in coming than a superficial glance across *Police Pictures* might suggest. The exhibition effectively displays the convergences between the discourses of race, heredity, and criminality in the nineteenth century, but it is not so acute at registering just how much cultural work and social conditioning it took to get the criminal portraits to 'speak' these languages." In "Archive or Art?" *Art Journal* 58:2 (summer 1999), 116.

All the portraits in the central section of this book were made (in a few cases adapted) to be part of a convict's prison dossier, commonly called a "jacket." The photographers who took these portraits were, in all likelihood, untrained in the photographic arts. Some may have been photographers outside the wire (everybody was something outside the wire), but they could, and most probably did, learn all the necessary techniques from the prisoners already working in the room where the pictures were made when they were first assigned to work there. They had no need to learn how to use filters to bring out features in different kinds of skin or to make the sky or clouds lighter or darker; they had no need to learn about different photographic emulsions or printing papers; they had no need to learn how to change the mood of the lighting to fit the desires or personality of the sitter. The ultimate consumer of these images was the dossier, and it desired as little variation or art as possible.

Either from previous knowledge or from current apprenticeship, these photographers had to know only how to make pictures like this: They had to know how to operate their portrait cameras, where to position the camera and the subject, how to set up the lights, and what these kinds of photographs of people were supposed to look like. The men and women facing their cameras had some idea what face they were supposed to present to that camera in that situation. If the photographers or sitters knew much more, the people who required these pictures to be made didn't have use for or interest in that knowledge.

Which is to say, these were culturally situated and coded photographic moments, in exactly the same way as are photographs at a wedding or family gathering, a school graduation, an award ceremony, an inauguration. All are situations in which the persons making the images and the persons whose images are being made apply—in that moment when the shutter opens, then closes—what they know of the immediate context and of the specific and appropriate image tradition. Most do it, I suspect, without conscious thought, as if it were something they have been doing their entire lives, which, in one way or another, they have.

MUGSHOTS

Second only to coroners' photographs of the newly dead, prisoner identification portraits are perhaps the least merciful, the most disinterested, the most democratic, and the most anonymous portraits of all.

The sitters have no interest in the photographs being made. They will never receive copies of them and will in most cases never see them.

The photographers who make prisoner identification portraits have no interest in the photographs they are making. They never sign their work, and they get to maintain no portfolio of it. As far as the institution assigning them such work is concerned, the photographers are fungible.

Studio portraits are about how someone wants to look or how the photographer wants a person to look, but identification photographs strive for the literal. The identification photographer avoids interpretation, ambiguity, and mystery. Lighting may change over time, as new equipment becomes available, but the reason for the change is always utilitarian, never aesthetic.

Arrest identification photographs, or "mugshots" as they are commonly called, differ from prisoner identification photographs. Arrest mugshots usually depict people in street clothes whose faces evince the transient condition of a person just taken into custody: the bored expression of someone who has been in front of that police camera many times in the past, the fearful or puzzled expression of someone before it for the first time, or the intoxicated, barely comprehending expression of someone high on alcohol or other drugs.[3]

3 Mugshots on wanted posters and in dossiers seem to have been invented in the 1860s by the Pinkerton National Detective Agency, which first used drawings of wanted criminals and then shifted to photographs. The modern practice, writes Allan Sekula, was developed by Alphonse Bertillon, director of the Paris Prefecture of Police in the late nineteenth century: "Bertillon was critical of the inconsistent photography practiced by earlier police technicians and jobbers. He argued at length for an aesthetically neutral standard of representation: 'In commercial and artistic portraits, questions of fashion and taste are all important. Judicial photography, liberated from these considerations, allows us to look at the problem from a more simple point of view: which pose is theoretically the best for such and such a case?' Bertillon insisted on a standard focal length, even and consistent lighting, and a fixed distance between the camera and the unwilling sitter. The profile view served to cancel the contingency of expression; the contour of the head remained consistent with time. The frontal view provided a face that was more likely to be recognizable within the other, less systematized departments of police work. These latter photographs served better in the search for suspects who had not yet been arrested, whose faces were to be recognized by detectives on the street." Allan Sekula, "The Body and the Archive," *October* 39 (Winter 1986), 29–30. The quotation is from Alphonse Bertillon, *La photographie judiciare* (Paris: Gauthier-Villars, 1890), 2, Sekula's translation.

People having their pictures taken in the police station or jailhouse face an uncertain future. Even if the police have them cold, neither they nor anyone else knows what kind of sentence they're going to get: will it be the minimum or the maximum, or will the heavens open and the lawyer get them off on a technicality, or the police lose the key piece of evidence, or the one witness who connects them with the event suffer amnesia? Arrest photographs document a moment rich in possibility.

All possibility is foreclosed in prisoner identification photographs, and the faces in them are almost uniformly tranquil. The individuals sitting for those photographs have already been in jail, through trial, and unambiguously removed from ordinary life. First-timers may not know what will happen to them in prison, but there is no doubt about the fact that they are there, nor is there any doubt about the minimum number of years they will spend there. The same bus or van that delivered them to the prison carried their commitment papers giving the warden control of their bodies and telling the warden how long that control is expected to last.

In theory, the prisoner identification portrait has no aesthetic beyond the literal: does it look like the person sitting in that chair or standing against that wall? If it does, the portrait is satisfactory; if it doesn't, it is unsatisfactory. It is, in theory, solely utilitarian.

But between the theory and the photograph stapled in the dossier falls the reality of the image. These portraits are far more resonant than the sitters or the photographers or the officials controlling both of them ever imagine. Each is different from every other; there is nothing automatic about them.

Rather, it is the free-world formal studio portraits with their improbable backgrounds and poses that, in time, look artificial, as in fact they are. "I infinitely prefer," wrote Henri Cartier-Bresson, "to contrived portraits, those little identity-card photos which are pasted side by side, row after row, in the windows of passport photographers. At least there is on these faces something that raises a question, a simple factual testimony."[4]

He could have been describing the famous Walker Evans 1936 photograph of penny portraits in the window of a Birmingham photographer.[5] It comprises three blocks of five images across and five blocks of three down: 225 images, every one of them photographed under identical conditions by the same photographer, and every one of them unique and individual. (And he could have been describing the

11

4 Henri Cartier-Bresson, *The Mind's Eye: Writings on Photography and Photographers* (New York: Aperture, n.d.), 31–32.

5 Library of Congress negative LC-USF342-008097-A.

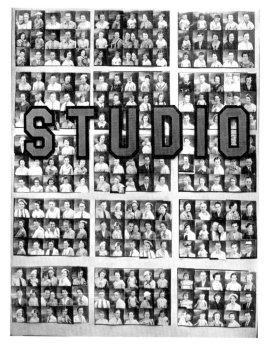

minimalist studio portraits by Heber Springs, Arkansas, photographer Mike Disfarmer, whose work and its relation to these prison portraits we'll get to further on.)

In 1971, Paul Cummings asked Evans, "Would you describe what makes a good photograph?" Evans's response fits every one of those photographs, his own photograph of that window, and every image in this book. His response: "Detachment, lack of sentimentality, originality."[6]

The images in *Pictures from a Drawer* are from a drawer in a particular prison in a particular place, but they could as well have come from a similar drawer in a similar prison in Texas or Louisiana or Florida or California or Arizona or Pennsylvania or Oregon. Or, for that matter, China or Singapore or Russia or Iraq or Kazakhstan or Mexico or Italy. There are things in these images specific to the time and place these images were created, and there are things in and about them of far wider moment.

BLACKBIRDS

Pictures from a Drawer is part of a large group of works in various media about prison as a cultural site.[7] My fieldwork for the project took place primarily in Texas and

6 Paul Cummings, *Artists in Their Own Words* (New York: St. Martin's Press, 1979), 99.

7 Some of the works in that project are my books *Cummins Wide: Photographs from the Arkansas Penitentiary* (Center for Documentary Studies and Center Working Papers, 2008), *Law and Disorder: Criminal Justice in America* (University of Illinois Press, 1985), *Death Row* (with Diane Christian, Beacon Press, 1980; French ed., *Le Quartier de la mort*, Paris: Terre Humaine, Editions Plon, 1985; 2nd French ed., with additional photographs, 1986), *Killing Time: Life in the Arkansas Penitentiary* (photographs; Cornell University Press, 1977), *"Get Your Ass in the Water and Swim Like Me": Narrative Poetry from Black Oral Tradition* (Harvard University Press, 1974; Routledge 2004 ed. with new CD), *Wake Up Dead Man: Afro-American Worksongs from Texas Prisons* (Harvard University Press, 1972; 2nd paperback ed., with additional photographs and new introduction, University of Georgia Press, 2000), *In the Life: Versions of the Criminal Experience* (Holt, Rinehart and Winston, 1972: French eds. with title *Leurs Prisons*, preface by Michel Foucault, Paris: Terre Humaine, Editions Plon, 1975, and with new signature of my photographs, 1978), *A Thief's Primer* (Macmillan, 1969; paperback title *Outside the Law*), plus chapters in *The Story Is True: The Art and Meaning of Telling Stories* (Temple University Press, 2007) and *Disorderly Conduct* (political and social essays, University of Illinois Press, 1992); as well as the documentary film

Arkansas, but also in Missouri, Indiana, Massachusetts, New York, and California during the years 1962 through 1979. I did additional work in New York during the Attica prisoners' civil rights trial (resulting from abuses during the retaking of the prison in September 1971) in 1991 and 1992.

I couldn't deal with some of that twentieth-century material—such as panoramic photographs I took in Cummins prison in 1975, and the prisoner identification photographs in this book, which I also acquired in Cummins that same year—until I had access to technology available only in the twenty-first century. More on that later.

If there is a structural model for the overall project it would be Wallace Stevens's poem "Thirteen Ways of Looking at a Blackbird." Each of the books, journal articles, films, recordings, and photo exhibits begins with primary work done in prison or based on events that took place in prison, but each stands alone, and many are purposefully contributions to multiple regimes or disciplines. *Killing Time: Life in the Arkansas Penitentiary* (1977) and *Cummins Wide: Photographs from the Arkansas Penitentiary* (2008), for example, document life in one particular southern prison, but they are also books of photographs like other books of photographs. *Wake Up Dead Man: Afro-American Work Songs from a Texas Prison*, and the film and the several phonograph records and CDs based on the same body of field recordings, document one survival technique utilized by black prisoners in a southern agricultural prison system; they are also contributions to African American studies, folklore studies, traditional music, and poetics. *A Thief's Primer* (1969) and *Out of Order: Versions of the Criminal Experience* (1972) are ethnographic studies of criminal work and prison life; both are also experiments in oral history and personal narrative. So was *Death Row*, the documentary film (1979) and book (1980) I did with Diane Christian, which is about the special prison Texas had for men under sentences for death; the film is also a social documentary.

Likewise the images in this book, which are drawn from a group of 178 prisoner identification photographs made, in all likelihood, between 1915 and 1940. I took them from a drawer in Cummins penitentiary in November 1975. They add to the work I've done on the Arkansas prison system and prisons in general. They document

13

Death Row (I was director, sound, editor, and producer, with Diane Christian, 60 min., 1979. *Death Row* was released on DVD in 2007. The disk includes a slideshow of 72 photographs from Death Row in Texas); essays, photos, and photo-essays in *Society/Trans-action, Texas Observer, Southern Cultures, New York Times Magazine, Acoma: Rivista Internazionale di Studi Nordamericani, Contexts, Latinoamerica, Journal of American Folklore, Nagyvilág, Atlantic, Harper's, New Republic, Nation, Western Folklore, Southern Folklore Quarterly, Criminal Law Bulletin, Texas Monthly, Houston City, Visual Sociology Review, Artvoice, Qualitative Sociology, Buffalo Report,* et al.; and eight phonograph albums and CDs.

the way prisoners were photographed in that prison system and others in the first half of the twentieth century. They are also pieces of evidence subject to various modes of interpretation and analysis. And they are photographs, astonishing photographs, which I think it useful to see not just in their own right as images and in the context of prison, but also in the broader context of Western portraiture in general and photographic portraiture in particular.

All art exists in the context of all other art, if not in the hand and mind of the artist, then in the eye and imagination of the viewer. When we look at these images, it is in terms of portraits we have known. Neither the photographers nor we could or can subtract our previous visual experience from the moment of these encounters.

CUMMINS PRISON FARM

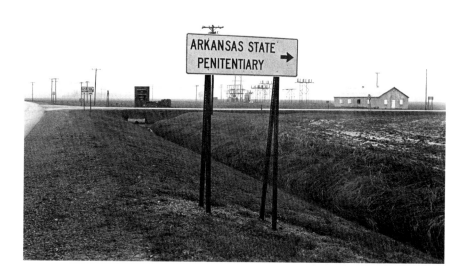

I had visited Cummins seven times previously, beginning in August 1971 when, during a drive from Buffalo to San Francisco with my dog Lulu, I stopped off to visit Terrill Don Hutto, who had been a schoolteacher and then warden at Ramsey prison farm in Texas when I had done research on black convict worksongs in Texas prisons several years earlier. Hutto had recently become commissioner of the Arkansas prison system, which was reputed to be one of the most miserable prison systems in the United States. Conditions had been so bad before Hutto was hired that a federal

judge had declared the system unconstitutional. Just being confined there, the judge said, constituted cruel and unusual punishment.[8]

The armed man in khakis who stood guard at the barrier on the road into the prison from U.S. 65, a north-south highway running from Minnesota to Louisiana, asked me if I had any weapons in the car. He was a convict, a lifer. I said "Yes, a .22 rifle." He told me to keep it locked up while I was on the farm, stepped back, raised the barrier, and waved me in.

I stayed a few days, wandering around the building, driving around the farm, talking with prisoners, Hutto, and the prison's assistant superintendent, Mike Hawke, whom I'd known as a field major at Ramsey. Hutto gave me the same freedom to roam as I'd enjoyed in Texas, where George Beto had been commissioner during the years I'd done my work there.

I sat much of one afternoon on a levee with two shooters watching hoe squads working in a field below. Lulu ran along the top of the levee, then chased something down the far side toward the Arkansas River. After a while she came back, bored or tired, and went to sleep in the shade of the car. One of the shooters told me that all the armed men in khakis overseeing the convicts as they worked were prisoners like himself. "Free-world guards are in blue," he said. I said I hadn't seen any guards in the field in blue. "They're in the building," he said.

15

8 *Holt v. Sarver,* 300 F. Supp. 825 (1969).

The guards working close to prisoners, he told me, carried only pistols so if the convicts pulled one off his horse they wouldn't have a weapon that would do them much good. He pointed to another man in khaki on a horse some distance from the working squads. "The high rider," he said—a convict guard armed with a rifle rather than a pistol, whose job it was to shoot anyone who ran off from a squad or who attacked the other guards.

"And you?"

"The two of us look for anything out of the ordinary," he said. I asked if he'd ever shot anyone. No, he said, he hadn't.

"Would you?"

"I guess."

I shot nine rolls of 35mm film during that visit, then continued on to California. A year later, Lulu and I reversed the trip, accompanied this time by my ten-year-old son Michael. There had been many changes. Most notably, the convict guards were gone, replaced by blue-uniformed free-world guards. I spent more time walking the corridor, hanging out in the barracks, driving around the fields, and taking pictures—twenty-nine rolls this time.

One day during my fourth visit, in 1973, I was driving to the cotton field when Cooter, the convict who worked in the truck weighing station, waved me in. I drove up the ramp and parked on the scale and went into the little shack where he worked. Cooter's name was Charles Hackney, but I never

heard any guard or convict call him that. Cooter had only one arm, the result of an automobile accident years earlier.

He gave me a legal-size pad of yellow paper. "After you left last time," he said, "I got to thinking about those questions you were asking me about what it was like here in the old days, and after I got this job I started writing some of them things down. I didn't think I'd ever see you again, so it wasn't for you. But I didn't want to forget those things neither, and I'm alone out here most of the day, and there's not much of anything to do when the trucks aren't up being weighed. I think about a lot of things out here. I didn't write it for you. I wrote it for me. What I wrote in there, them things happened like that." The pad was a series of straightforward narratives about Cooter and atrocities he had seen in Cummins prison in the 1950s. They were the kind of narratives that had moved Judge J. Smith Henley to declare the prison unconstitutional in *Holt v. Sarver* in 1969. Cooter's yellow pad describes a Cummins closer to the Cummins experienced by the prisoners whose images appear in this book than anything I ever saw, so I've included it as an appendix, starting after the final photograph.

That same day, a convict who in his spare time fixed wristwatches told me he'd seen me in Ellis prison in Texas years earlier and that he'd known of people who'd said things to me they shouldn't have but no one had ever gotten into trouble for any of it, so he'd decided I was a trustworthy person. "That's why these guys are talking to you so freely," he said. "I told them you were okay." He grinned when he finished telling me that and said, "Ain't it something when somebody knows more about you than you know about him?"

I continued visiting Cummins. At first, my interest was to chronicle Hutto's attempt to pull it out of the nineteenth century. Then I realized that I wasn't writing a book at all: I was spending most of my time taking photographs and I was documenting Cummins visually. In the course of my eight visits, I took more than four thousand photographs, most with two Nikons, then on the last two visits, both in 1975, with a Leica M4 and a Widelux, a 35mm camera that has a 26mm lens mounted on a rotating turret so it makes an image 126° wide covering almost two frames (24mm, 35mm, and 50mm lenses on a 35mm camera, by comparison, have images that are 74°, 54°, and 40° wide, respectively).

I was able to exhibit and publish the Nikon and Leica images soon after I stopped visiting Cummins prison farm in 1975.[9] The Widelux images were another matter: I couldn't do anything useful with them for 30 years. When I printed them in

17

9 More than 100 of those images are in Bruce Jackson, *Killing Time: Life in the Arkansas Penitentiary* (Ithaca: Cornell University Press, 1977).

the darkroom in the 1970s, they came out smaller than regular 35mm images. Here's why: if my largest printing tray was 20" long, and if I wanted at least a 1" margin all around, then the largest print of an ordinary 35mm negative I could make would be 18" × 12". But if I printed the double-width Widelux negative that same maximum width—18"—the print was only 7.5" high. And there were technical problems that made them difficult to control in the printing as well. It wasn't until this century, when I began printing digitally and could use roll paper that let me make images on 17" × 38" sheets, and had Photoshop CS3 to let me deal with the technical problems, that I could print the Widelux images the way they need to be printed.[10]

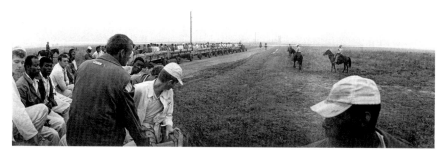

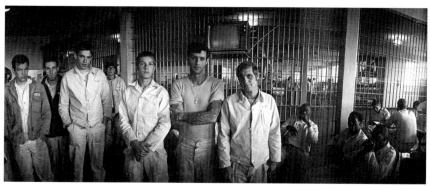

So with all those cameras and all those frames of film, I was certain, by the time I neared the end of those last visits to Cummins in late October and early November 1975, I had acquired all the images I needed or would ever have to document life in that place.

10 Bruce Jackson: *Cummins Wide: Photographs from the Arkansas Penitentiary* (Durham and Buffalo: Center for Documentary Studies and Center Working Papers, 2008).

I was wrong. There was another group of images I would acquire on that trip, and they, too, had to wait for twenty-first century technology before they could be made accessible.

PICTURES IN A DRAWER

I was walking along the corridor leading from the outside world to the interior of the main building when one of the convicts who took the identification photographs for the prisoners' jackets beckoned me into the room where he worked.

I went in. He looked both ways in the corridor then shut the door.

"This will interest you," he said. He opened a drawer. In it were hundreds of small loose prisoner identification photographs. "Help yourself," he said.

"Don't they belong to somebody?" I said.

"Just the state. Fuck 'em. Help yourself."

I did as he suggested. I stuffed photographs into my jacket pocket and stopped only when a guard came into the room to look for something, then sat down at the desk and began smoking. He gave no sign of leaving, and I had no particular reason for being there, so after a while I left.

I suppose I could have continued stuffing my jacket pockets while he was there— these were unneeded duplicates of photographs in files that hadn't been opened for decades, and the guard knew I had been allowed to go wherever I wished in the prison without supervision or oversight, so he probably wouldn't have interfered with my theft—but that didn't occur to me until long after.

I planned on coming back later in that visit to grab the rest of the photographs, but I got busy with other things and didn't get to it. No matter, I thought. I'll get to it next time.

But there was to be no next time: I was never inside Cummins prison again.

2
RESTORING THE EYES

THE PHOTOGRAPHS

I HAD PICKED UP 98 loose photographs and two small brown envelopes, one containing 61 photographs of women, the other, marked "12,300," containing 19 photographs of men, some of them duplicated in the loose photographs.

Among the loose photographs, one was of a black woman. All the other loose photographs were of men. All the women whose photographs were in the envelope were white. I don't know if there was another envelope in that drawer with photographs of black women convicts or if they and their photographs had been kept somewhere else.

Most of the photographs of the men had been taken inside, against a wall or a cloth; most of the early photographs of the women had been taken outside, near a fence, with them sitting in a wicker chair.

The faces are fixed and unmoving, long dead men and women when they were in their youth and middle age. Time has altered the color of the paper and the density of the images, and many show physical evidence of moments when they weren't left in a drawer waiting to be found: the red rust of a onetime paper clip, the bright steel of a staple, the deliberate or accidental mark of a pen. One of the things these fixed images is about is time itself.

IN THE BOX

I put the photographs in a cigar box and for a while forgot about them. It was obvious from the few that had dates on the signs hung around the prisoners' necks or written on the backs that they had been made long before anyone I'd met in Cummins had ever been a prisoner there.

Over the years, I'd remember them and sometimes I'd look at them. I long thought they ought to be printed large. Small, they were artifacts, antiques, faces without names, names without contexts.

In portraiture, as in many things, size matters. The pleasure of the miniature is the way it draws attention to detail by making it apparently exact while far smaller than the real life original; the power of the large portrait is the way it overwhelms the ordinary. The function of the prisoner identification photograph, which is always small, is to fold a person into the controlled space of a dossier.

They were originally printed small because each was destined to be a fact in a bureaucratic process. Bureaucratic processes trivialize and reduce human life and experience; they discard everything but what concerns the bureaucracy creating and maintaining the process.

The dossier, the jacket, contains the past and the future, at least insofar as the criminal justice system is concerned. Who are you in a prison? You are what your jacket says you are, nothing more, nothing less. If you say, "But the jacket has it wrong!" The response is, "How can the jacket have it wrong?"

In time, all prison jackets thicken. Not with trial records (those are stored elsewhere) and neither with parole or post-release records (those are other institutions' responsibilities). The only outside documents are the prisoner's rap sheet listing arrests and previous convictions and the court's commitment papers empowering the prison system to take custody for however many years. Everything else in the prison dossier is about the person's life in prison. It thickens with documents about that: reception papers, medical examinations, disciplinary reports, parole board decisions, fingerprints, school grades, photograph at admission, photographs as the years go by. Get fat and they'll take another picture. Lose your hair and they'll take another picture. Get old and they'll take another picture. The newer photographs don't displace the older photographs; they join them, as in a family album. Nothing is discarded. When you die the final document—the death certificate—joins all the others and the jacket is stored with all the other dead files.

The thicker the jacket, the more it displaces the individual of which it is simulacrum.

That is the function of a bureaucratic dossier of whatever kind—military, medical, academic, corporate, police, prison: turning the infinitude of facts and emotions and connections that make each of us the ever-changing unique creatures we are into manageable things. Manageable things of this order are not alive; they are useful abstractions or constructs.

21

Printed large, the images in *Pictures from a Drawer* again depict individuals, people who had substance and weight in this world. They look at us even as we look at them. ("When you look at an icon," wrote Robert S. Nelson and Kristen M. Collins in their study of religious icons from the Sinai, "the icon looks back."[1]) You can't trivialize faces when they're printed large. You can't staple them to an inner page of a folder and close the folder and file the folder away in a box or drawer that will never again be reopened. Printed large, their eyes meet your eyes. Across time, their eyes meet your eyes.

RESTORING THE EYES

If the only problem were size, I could easily have rephotographed the images and made enlargements from the new negatives. More difficult was the yellow patina on many of them that obscured detail. Until very recently, removing most of the patina without destroying the effects of time entirely and then adjusting the contrast and tonal range to preserve the actual image could be done in a good lab, but only at great cost. That kind of color work couldn't be done in an ordinary darkroom. I tried to get grants for lab costs to make and edit enlargements, but got nowhere: who cares about pictures of long dead convicts from a small southern state?

Digital image processing technology available in the early years of the twenty-first century changed everything about our access to images made in the first third of the twentieth century. It abrogated time. What couldn't be done in the darkroom can now be done at the desk. I was not only able to restore the images, but to bring them to different states, first on the monitor and then in prints, until I achieved what seemed to me a reasonable balance between what they might have looked like originally and what they had experienced in the interim.[2] These are old pictures, and time hasn't been good to some of them; what we see now should reflect the experience the prints themselves have had, but not at the price of making it seem that all the sitters had a bad case of jaundice.

My goal in working with these images wasn't to make them appear new. Were that the case, I would have removed the scratches, foldmarks, and discolorations— easy to do with the software available now. Rather, it was, first, to restore the subject's gaze, which both the small size of the original photograph and the ravaging of time

1 Robert S. Nelson and Kristen M. Collins, eds., *Holy Image, Hallowed Ground: Icons from Sinai* (Los Angeles: J. Paul Getty Museum, 2006), 121.

had served to obscure. And second, to do that restoration without fully undoing the effects of time.

The subject's gaze is, I think, the most important element in portraiture in all media, and is part of its power and authority. This is the same with these prisoner identification photographs and, for example, the Greek funerary portraits on wooden tablets, celebrated for their highly stylized eyes, which were inserted in mummies at the Egyptian oasis of al-Fayyum.[3]

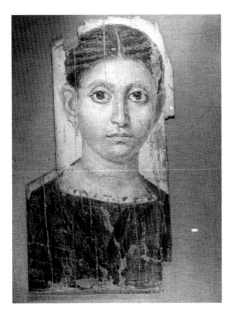

In all such portraits, the subject looks through the artist at the viewer. At its best, it seems as if no artist had intervened. Sometimes it doesn't matter if the eyes are closed or if the subject turns aside, for when the eyes are closed or the subject turned,

2 I scanned all the prints on an Epson 4490 scanner at 1200 dots per inch and 16-bit pixel depth. This made for large files—around 150 megabytes for the single images and 300 megabytes for the front and profile images—but the large files reduced the likelihood of dark tones blocking up when I adjusted the levels. I tried scanning at a higher dot per inch setting, which made for truly monstrous files but produced no discernable improvement in the prints, even when I went beyond the 13"× 19" sheets I used for exhibitions. Beyond that and the detail of the original images began to break down, whatever the resolution of the scan, a consequence of my originals being small prints rather than the negatives or plates from which they had been made. I did all the work on a PowerMac G5 Quad, using Adobe Photoshop CS3 for the initial color exhibition prints and Adobe Lightroom 1.3 for the greyscale prints that were the basis for the duotones in this book. I printed on an Epson 4800 Pro using Epson UltraChrome inks.

then the denied gaze is part of the portrait in the same way that silence, at the proper moment, can be as or more eloquent than words.

UNDOING TIME

When color film fades there is a shift of what remains toward magenta, the last color dye to go. When faded color film is transferred to digital format, a good colorist can often find the whites in a scene and expose for them, bringing back much of the original color. It's not the same as the original because information in those absent color zones has been irretrievably lost. The colors in the restored image may be more or less perhaps right, but the sharpness of the original isn't there because that information is missing.

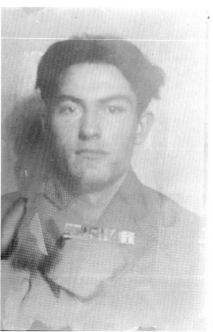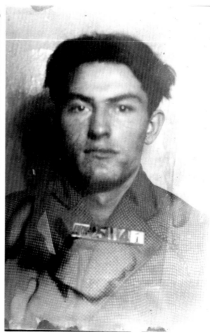

24

What's going on here isn't quite like that. The yellow on the prints I took from that drawer in Cummins prison isn't the result of color subtraction—there wasn't some other color originally, parts of which faded over time giving us this yellow result. The originals were monochrome, not color, images. The yellow exists

3 These portraits were made from the late first century BC or early second century AD to some time in the third century AD. The al-Fayyum portrait is a public domain photograph (http://upload. wikimedia.org/wikipedia/commons/3/35/Portrait_du_Fayoum_01a.jpg, accessed December 22, 2007) of an original in the Louvre, accession number AF6884.

even in the non-image white border areas some of the photographs have. The yellow seems to be something that came over the images rather than a major change within them. The process is closer to what happens to a brass sconce than what happens to color film.

I found that simple reduction in saturization of yellow often revealed detail that the yellowing had obscured. Some details were there all along, but they were coated by the yellow patina of time. Then I worked with density until I had what seemed a balanced image—not so dark in the blacks as to block out anything that hadn't been blocked out previously and not so light in the highlights to wash out what detail remained.

If I had been trying to rescue the images as I might for a family friend with old photographs of long-dead family members, I'd have gone about the restoration work very differently. I would, for example, have gotten rid of the paper clip rust marks, the scratches, the crease marks, and I'd have repaired the rips. But here, all of those marks were part of the prints' own histories; they are, in a sense, each print's gaze. I would also have gone about it very differently if I had been working from the original glass plates or sheet film negatives from which these photographs had been printed. If I'd been working with those negatives, I'd have made the prints exactly as I make digital prints now from scans of my own negatives from the 1960s and 1970s. Each kind of restorative print work has a different visual vocabulary that must be honored.

3
SIZE

THE MEN'S PRINTS occur in several sizes: 3"× 5" and 3.5"× 5" are common for the single images; 4.75"× 6.75" for the doubles. Some have borders; some do not. The actual images in the men's prisoner identification photographs range from 3"× 2.75" to 5"× 3.5".

The smaller double shots are flat, unfolded. Many of the larger ones are folded, and many of these have separated. #12353 came in two versions—smaller size unfolded, stained on the right; larger size folded.

Most of the prints contain two pictures—a front view and a profile. With one exception, the profiles are always on the left, frontals on the right. The exception—#9038—had been printed wrong side up, thereby reversing the image.

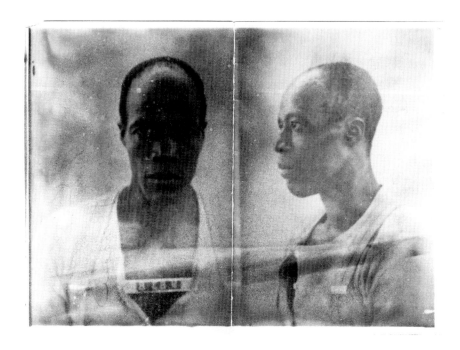

Most of the women's photographs are 2.12"× 3.12" on 2.5"× 3.5" sheets, or 2.87"× 4.87" on 4"× 5" sheets. Many of them are glued to heavier backing, like a very thick manila file folder, or even heavier than that. Some of the men's photographs are stapled to 3"× 5" index cards. Some of those index cards have typing or writing on the back, but most do not. The stapling seems simply a way to keep together the halves of a photograph from coming apart at the fold.

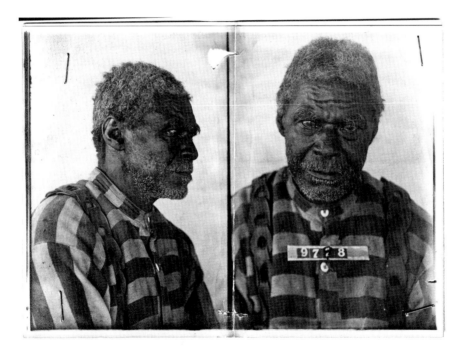

Only seven of the 61 photographs in the envelope marked "Women" are in the traditional mugshot profile/frontal format; all the others are from the front. A few of the earlier women's photos—such as #124 and #153, discussed in Chapter 5—are more snapshots than mugshots. Only the signs around the women's necks in those two photographs reveal the genre. Both of those photographs are printed to the edge. Most of the women's images are printed with a white border, more like ordinary free-world photos than prisoner identification photographs.

A few of the men's photographs really are free-world photographs. #12333, for example, is a single 4"× 6" picture of a man in tie, stickpin, street shirt, and vest. It has neither the shape nor size of a prisoner identification photograph. Only the number

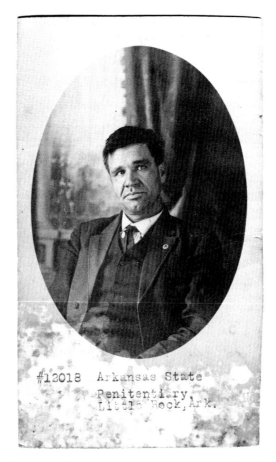

written on the back transforms it into and announces it for what it is. Likewise, #12018 is a photograph of the kind that would be taken in a shop and inserted in an oval frame to be given to a mother or a lover.

The card measures 3.2" × 5.5", with the oval photograph itself measuring 2.8" × 3.4". The man wears a three-piece suit with a pin in his jacket lapel and another in his necktie. Behind him are a window and drapes. This free-world studio photograph becomes a prisoner identification photograph only because of the number and six words typed on it: "#12018 Arkansas State Penitentiary, Little Rock, Ark." Without that typing, the photo would be at home in a small metal frame on a mantel, a table, or bed stand—and probably at one time was.

4
DATING THE IMAGES

THE FIRST ARKANSAS prison was on the site of what is now the state capital in Little Rock on a tract purchased in 1839. In 1899, the penitentiary moved to a site southwest of Little Rock. The building known as "The Walls" opened there in 1910. Earlier, in 1902, the state had bought 10,000 acres for Cummins farm and began sending inmates there that year. The Walls was closed in 1933, and male prisoners were shipped to Cummins and Tucker farms. White women prisoners were moved to Cummins prison farm in 1951. Black women inmates were already there.

MEN

The image of Pad Mullins is blurred beyond recognition:

But a note glued to the back of the print tells us his name and number (#23035), that he is white, has tattoos, and was eighteen in 1925 when he was admitted.

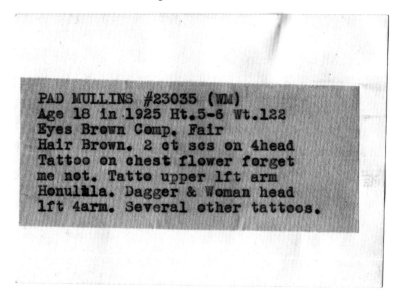

PAD MULLINS #23035 (WM)
Age 18 in 1925 Ht.5-6 Wt.122
Eyes Brown Comp. Fair
Hair Brown. 2 ct scs on 4head
Tattoo on chest flower forget
me not. Tatto upper lft arm
Honulula. Dagger & Woman head
lft 4arm. Several other tattoos.

The highest male number in the group of images from the drawer is #28518. Notes typed and pasted to the back of that photograph identify prisoner #28518 as "J. W. (Walter) Morris, escaped." The note requests: "Arrest and wire S. L. Todhunter, Warden, Little Rock, Arkansas," which means it was certainly before the Little Rock prison closed in 1933 and in all likelihood before 1930. Notes typed on the back of #8516 tell us the name of #8516 is Booker Thompson and that he was received "9-28-17" and discharged "12-20-18." The lowest number in the photographs of male prisoners is #6203.

Some of the photographs, however, are more recent. The chest sign on #23008 is dated 10-1-37. But since the photo of Pad Mullins, #23055, was taken in 1925, it is likely that the 10-1-37 photo of #23008 was taken to show what he looked like older, after he'd been in prison a while, or it was a release photo.

Assuming that the rate of commitments to the prison didn't radically change before Booker Thompson in 1917 or after Pad Mullins in 1925, we can assume that the men whose images appear here came to prison after 1915 and before 1930.

MEN IN COATS

The drawer contained two left and frontal photographs of #12318. They differ in several important regards. In one, he wears prison stripes; in the other a suit coat. His shirt under that coat is prison stripes. The collar on the two shirts is not the same, and his hair is combed very differently in the two photos, so it is unlikely that the photographs were taken the same day or even the same year.

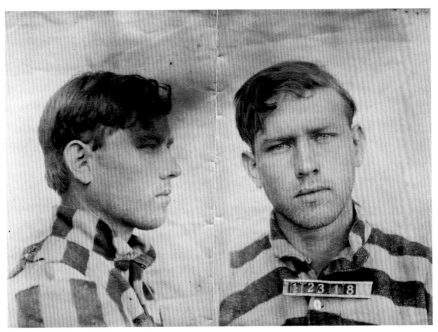

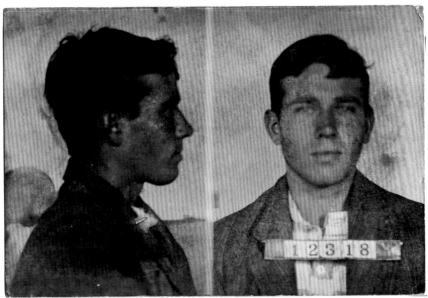

He is not the only convict so attired. #8114, #10351, and #25896 all wear free-world suit coats, as do men in several other photographs (often it is the same coat), but the shirts under those coats are convict stripes. Robert Eaton, #6203, wears a free-world hat and coat, but convict stripes for a shirt and a bowtie made of a convict stripes cloth. The coat on #25896 is far too large for the man wearing it. #21451 wears a cowboy hat and a coat—but the shirt is convict stripes and the coat seems far too big for him.

What's going on? Why would those men dress like that?

The answer—those men wouldn't dress like that; someone else would dress them like that—is suggested by the back of the card for Booker Thompson, #8516, one of the few with detailed information. It doesn't only tell us that he was received by the prison on 9-28-17, when he was twenty-one years old, with a two-year sentence for forgery. It also tells us that he was discharged five days before Christmas 1918—which means the note on Booker Thompson's prison ID photo was prepared at the time of his release from, rather than his admission to, prison.

Perhaps shortly before a man was released, the prison authorities would dress him up in the kind of hat and coat they thought he might wear in the free world, and that the pictures taken at that point weren't for identification within the prison but for identification outside, should he be arrested or sought for arrest after release. They are pictures taken not to identify someone in custody now, but rather to make it easier getting him back into prison the next time. This is the kind of picture you'd see on the post office wall if he did something substantial enough to be wanted by the police.

DATING THE WOMEN

Dating the women's images is more difficult. The only women's photos with dates on them are #188, #200, and #212—all dated "7-3-36" on their chest signs; #214 and #217, both dated "8-27-36"; and #26556, numbered in what seems to be the men's sequence rather than the women's.

Current Arkansas prison officials could perhaps provide exact admission dates for all these individuals, but they failed to respond to any of my inquiries about them. No matter. The images provide enough information on their own.

The hairstyle worn by #436 and #538, the highest number among the white women, was popular in the late 1930s, a time when women's hats were out of fashion.[1] The bubblegum curls on #439 date from the same period.[2] The hat worn by #124, the lowest number in the women's envelope, is a style popular in the 1920s. The hat on #153 is a style popular in the late 1920s and early 1930s.

The women's images, therefore, date from 1920 to at latest 1940, but probably a few years earlier.

1 See, for example, http://www.fashion-era.com/images/HairHats/original_hathair_images/1938_hats_hair.jpg (accessed May 31, 2007).

2 Cf. www.hairarchives.com/private/30s/30s2.jpg (accessed May 31, 2007).

5
THE WOMEN

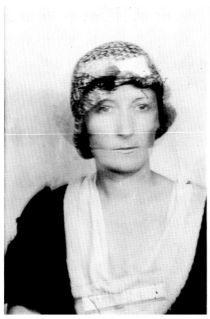 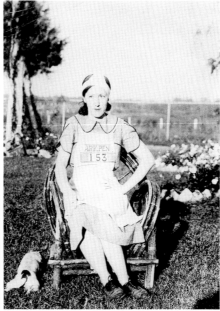

CLOTHING AND CHAIRS

THE WOMAN IN WHAT I take to be the oldest image in the women's group wears a white blouse with a deep loose neckline, and a dark jacket, wide at the neck and shoulders. Her expression is calm, almost detached, and her gaze is slightly to the right of the lens. The image isn't sharp. It's not so much out of focus as it is blurred by movement, either hers or the camera's. Were it not for the barely legible sign hanging from her neck that says "ARK. 124," it wouldn't seem to be a prisoner identification photograph at all.

After her, there is a group of women all wearing free-world clothes and all photographed outdoors in a handmade bentwood chair (#153–#174). One of them—#168—wears a pearl necklace. The earliest photograph in that group (#153)

is almost domestic: it is a wide shot, showing planted flowerbeds rimmed with stones and a clump of trees. The woman sits with her left arm akimbo, the hand high on her thigh, and with her right hand on her right knee. She wears a hat, a free-world dress, and an apron. A small dog sleeps alongside the chair. Were it not for the sign pinned to her apron—"ARK. PEN 153"—nothing would identify her as a convict and the location as a prison.

Three of the photographs in that group (#161, #164, and #168) have as backdrop a house with what seem to be French doors and a decorative shrub. All the others in that group—even the ones with shadows indicating they were almost certainly done outside (e.g., #169 and #170)—have as backdrop a sheet.

Several of the photographs with the bentwood chair have the chair more in focus than the faces, suggesting that, from shot to shot, neither the camera nor chair was moved and the lens wasn't refocused. I would guess that many of the bentwood chair group were photographed the same day, with the women told to sit there one after the other, with the same camera setup, and the photographer never realized he didn't have the eyes in sharp focus. If, as I suppose was the case, the photographer came to the women's unit only occasionally to photograph, he was perhaps unused to the need to adjust the lens for each shot. Back at the men's unit, where the bulk of his photography would have taken place, his camera and the subject's chair would have fixed spots; perhaps both would have been bolted in place, and the lights would always be in the same place and at the same level of brightness. The only adjustment would have been the height of the platform holding the camera, as in the photo on page 35, which I took in 1975.

So all the male prisoners would be positioned, lighted, and focused exactly the same. If the male prisoner sat where he was supposed to sit and didn't move, he'd be adequately lighted and his eyes would be in focus. The women's photographs, on the other hand, were all ad hoc. At the women's unit, where there were fewer images to be made, the photography took place less frequently and everything had to be brought to the site and set up there, which is why things sometimes fell from focus.

The bentwood chair is gone beginning with #188 (whose sign is one of the few that includes a date: 7-3-36) and so are, with only a few exceptions, the free-world clothes.

The 1936 women sit in a wooden folding chair with what looks like a sheet hanging behind them. The wooden chair has large dowels. The shadows on the sheet and faces in some of them (e.g., #214 and #217) suggest a bright lamp not much above head level to the left. These were probably done inside, since the lamp wouldn't be necessary outside.

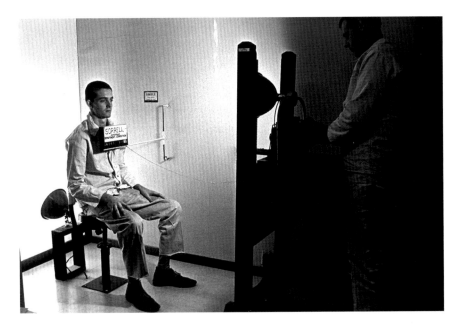

The chairs all but disappear after #217 (p. 165). Many of the later photographs are printed as if they were snapshots, waist-up frontal views centered with a white border. From #349 on (p. 166), none of the women wears the sign with the name of the prison, her prisoner number and the date. Some of the photographs have numbers written on the back, but many have no identifying information at all.

The clothing many of the women wear is shabby. There are patches just under the breasts of the woman on p. 117. The second button of the woman's blouse on p. 120 is missing. The jacket of the woman on p. 121 is missing a button and has a tear in the left arm. The left arm of the blouse of the woman on p. 123 is ragged, and the right arm is patched with mismatched material. The right sleeve of the woman on p. 163 (#200) is rags. The women smile, but their clothing is grim.

CALLIE BROWN

The only photograph of a black woman in the prints I took from that Cummins drawer is #26556, identified on a slip of paper glued to the back as Callie Brown. The slip of paper says that her two upper front teeth are gold (we can't see them in the photos) and the lobe of her left ear is off (in the photo both ears seem fine, though the right ear is partially covered by her hair). The note also says Callie Brown has a scar over her "left eye brow outer." We can't see that in the photos either.

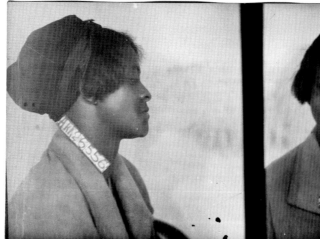
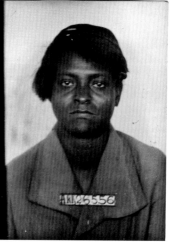

WANTED: ESCAPED: REWARD $25.00

CALLIE BROWN: BFM:Age 24: Eyes Bro
Hair Black: Compl. Black: Ht 5-2½
Wt. 134: 2 upper front teeth gold
Lobe of left ear off:ct.sc.left eye
brow outer: Vac. rt forearm outer
F.P.C. 31 IM 23 Ref: 31 IM 22
 28 OM 19 28 OO 18

Arrest and wire, S.L.Todhunter,
Warden, Little Rock, Arkansas.

The slip also says she has escaped, there is a $25 reward, and "Arrest and wire, S. L. Todhunter, Warden, Little Rock, Arkansas," which means this was 1933 or earlier, since 1933 was the year the prison in Little Rock was closed.

The other anomalous thing is her number, which is inconsistent with all the other women's numbers. Woman #200, for example, was photographed July 3, 1936, which puts that sitting later than Callie Brown's escape. Did the black women have a different set of numbers assigned to them? Were they assigned numbers in the same series as the men, which would be about right for Callie Brown?

Callie Brown wears free-world clothes. Perhaps these front and profile images were taken when she was admitted, and she lost the earlobe and got the scar between the time that photo was taken and her escape.

I left Callie Brown's photo where I found it: with the photos of the men loose in the drawer with whose prison numbers her number was a part.

THE DUCHESS OF ALBA

The women's photos have, by and large, a look different from the men's photos, and the women in them offer a different gaze. Many of them are photos of a kind that a person might give to someone else. Several of the women smile; more seem to engage the camera the way most people do—but in a way that few of the men in these prisoner identification photographs do. The men, for the most part, are there, and their photographs are being taken, and they are looking into the lens. The women, many of them, seem to have a place in the world and the camera is photographing them.

Am I eroticizing them? Were the photographers? Were the women prisoners, or some of them, eroticizing the encounter? Do women relate to a camera differently than men? Did these women? Did the prison photographers relate to them differently than they did to the men prisoners? Did the difference in photographic space influence the way the men and women presented themselves to the camera? Were the women's pictures taken in circumstances so different from the men that they reacted more like ordinary people having an ordinary photograph taken than prisoners in the ordinary, coercive prisoner situation?

There is no one to ask. These things are not done now the way they were then, the participants are all dead or approaching death, the photographers were anonymous and couldn't be tracked down anyway, and none of the participants in those prison portrait sessions the better part of a century ago left written records about how he or she was feeling while the picture taking was going on.

We can speculate, project back in time from what we know about how things are done now, and what we know of the way men react to men and the way men and women react to one another, and what we know of how things are in a prison.

With the men, the convict taking the picture has a high-status prison job; most of the male convicts being photographed are at a nadir, newly arrived, standing against a wall and told not to move. There's nothing overtly erotic about it; if there is anything ("He's so pretty") it is suppressed. Eroticism in men's sexual relationships in prison is, from what I've seen, mostly suppressed anyway. There's sex, but not much overt eroticism, and certainly not much tenderness. A stud has his punk whose orifices he utilizes; but they don't walk down the corridor holding hands. A prisoner who was gay on the streets might tailor his clothes a certain way and pluck his eyebrows, but the men with whom that convict has sex don't go all aflutter over it as they might with a woman on the outside.

The women posing for their identification photographs, however, are in a situation where they are being looked at and paid attention to by a man, which is as

rare for them in the prison situation as it is for the men doing it. Some of the women wear street clothes, which suggests they are new arrivals, but far more wear clothes that suggest they've been in the prison for a while: some are torn and patched, some are embroidered with the women's names, some are work outfits.

The picture-taking situation is itself out of the ordinary for both parties. The only women the men in prison got to see, other than on visiting day, were perhaps the officials' wives. With rare exceptions, eye contact with an official's wife would have been interpreted as and responded to as transgressive. The photo situation with the photographer as a brief visitor to the women's prison was perfect for a transient flirt, and if not that, a transient assertion of gender on the part of both photographer and the women being photographed. The men taking the photographs could afford to be softer while doing it, might even have enjoyed being softer while doing it.

What would it have been like coming from the world of the men's barracks to the women's prison and spending an afternoon, outside for the early ones, inside for the later ones? Surely it was different from taking pictures of male convicts, against the wall, in the room with the fixed chair and lights back in the main building.

Add to that the simple difference in the way the women were in the prison. The women at Cummins were all in a single building, and they slept in one large room. When I visited the women's unit in the 1970s, the women had knives and forks in their dining room (the men had only spoons), and they, the staff, and visitors ate the same food at tables a few feet apart (in the men's unit, guards and visitors ate different food in a separate dining room in a different part of the prison). There were two cells off the dining room for when someone got violent, but only one time did I see anyone in them.

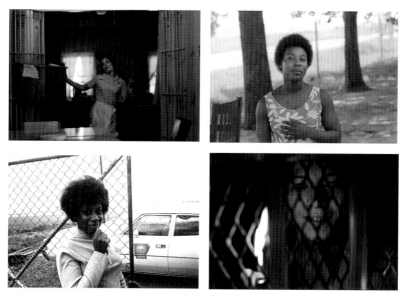

I made only a few photographs in the women's unit of Cummins during my eight visits. On the opposite page are four of them, two from 1971 and two from 1975.

I look at them and think about a man fifty years earlier coming over there from the men's unit with his camera on a tripod. He comes into their space rather than receiving new convicts in his space. They—the women and their supervisor—decide where the pictures will be taken. Perhaps the women prisoners did what girls and women do when they're about to have their picture taken outside of prison: go to the mirror and adjust their hair. I doubt that the men having their identification photographs ever said, "Wait a minute, I have to comb my hair," and I don't doubt that some of the women did.

And what about us now, at this distance of time, looking at these images in the tranquility and privacy we usually have when we look at a book of images? "There's an element of sexuality in all portraiture," observed the great fashion and portrait photographer Richard Avedon. "The moment you stop to look, you've been picked up. And you may look at a portrait with a concentration you're not allowed in life. Is there any situation in life where you can stare at the Duchess of Alba for half an hour without ending up dead at the hands of the Duke? A confrontational, erotic quality, I think, should underline all portraiture."[1]

1 "Borrowed Dogs," in Richard Avedon, *Portraits* (New York: Harry N. Abrahams, 2002); http://www.richardavedon.com/data/web/richard_avedon_borrowed_dogs.pdf (accessed December 6, 2008).

6
PORTRAITS

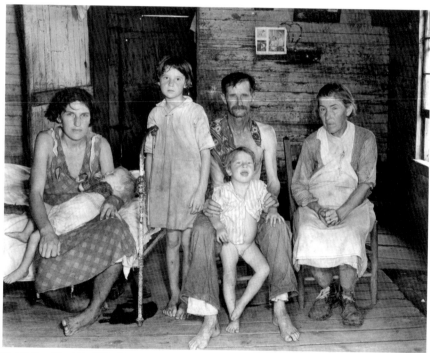

"Bud Fields and Family," by Walker Evans, 1936; Library of Congress LC-USF342-008147-A.

PRISONER IDENTIFICATION photographs are a subset of the genre of photography known as identification photos, which are in turn a subset of the genre of art known as portraits.

A portrait may be created to represent what the sitter or the artist thinks is the inner nature of the person as well as the external appearance of the person. They are as various as the temperaments, moods, conditions, and talents of the artists and the sitters: Leonardo's *Mona Lisa*, Velasquez's *Innocent X*, Piero di Cosimo's *Simonetta Vespucci*, Dorothea Lange's *Migrant Mother*, Walker Evans's photographs of three tenant families for *Let Us Now Praise Famous Men*, Robert Mapplethorpe's *Patti Smith*,

1975, nineteenth century *cartes de visite* (2.5" × 4" albumen prints mounted on cards) and cabinet prints (usually 4" × 5.5" photos mounted on 4.25" × 6.5" cards), the millions of portrait photographs generated every year by anonymous photographers in motor vehicle agencies, military boot camps, police booking rooms, and prison and college admissions offices the world around.

Henri Cartier-Bresson believed the portrait photograph capable of expressing the sitter's inner character, and he thought the photographer's task was to capture that expression at the most appropriate moment: "What," he asks, "is more fugitive and transitory than the expression on a human face? The first impression given by a particular face is often the right one; but the photographer should always try to substantiate the first impression by 'living' with the person concerned. The decisive moment and psychology, no less than camera position, are the principal factors in the making of a good portrait. It seems to me, it would be pretty difficult to be a portrait photographer for customers who order and pay since, apart from a Maecenas or two, they want to be flattered, and the result is no longer real. The sitter is suspicious of the objectivity of the camera, while the photographer is after an astute psychological study of the sitter."[1]

Richard Avedon disagrees: "The point is that you can't get at the thing itself, the real nature of the sitter, by stripping away the surface. The surface is all you've got. You can only get beyond the surface by working with the surface. All that you can do is to manipulate that surface—gesture, costume, expression—radically and correctly."[2]

In an article on his famous portrait of Henry Kissinger, Avedon wrote, "A photographic portrait is a picture of someone who knows he's being photographed, and what he does with this knowledge is as much a part of the photograph as what he's wearing or how he looks. He's implicated in what's happening, and he has a certain real power over the result. The way someone who's being photographed presents himself

1 Henri Cartier-Bresson, *The Mind's Eye: Writings on Photography and Photographers* (New York: Aperture, n.d.), 31.

2 "Borrowed Dogs," in Richard Avedon, *Portraits* (New York: Harry N. Abrahams, 2002); online at http://www.richardavedon.com/data/web/richard_avedon_borrowed_dogs.pdf (accessed December 6, 2008).

to the camera and the effect of the photographer's response on that presence is what the making of a portrait is about."[3]

Then, a few years later in an interview for *Egoïste*, he reversed himself: "I used to think that it was a collaboration, that it was something that happened as a result of what the subject wanted to project and what the photographer wanted to photograph. I no longer think it is that at all. The photographer has complete control, the issue is a moral one and it is complicated. Everyone comes to the camera with a certain expectation and the deception on my part is that I might appear to be indeed part of their expectation. If you are painted or written about, you can say: but that's not me, that's Bacon, that's Soutine; that's not me, that's Celine."[4]

Identification photographs are a genre of the literal: they are not made to express the essence of the subject or skill of the photographer, but rather to capture enough of what a person looks like so a stranger—a policeman writing a ticket or making an arrest, a security official at an airport, a librarian, a military paymaster, a bank teller— will look at it and decide, with some measure of confidence if not certainty, "Yeah, that's you."

Applicants for driver's licenses know the licenses will not only let them drive a motor vehicle legally, but will also let them cash checks, board airplanes, get a library card, and any of the countless other things requiring official photo identification. Newspaper reporters know the photo ID press card hanging around their neck on a chain will get them into briefing rooms or past police lines from which the general public is barred. International travelers need passports to enter and leave countries. Students and professors use their university ID cards to get books out of the library.

It is in the interest of all users of such documents, therefore, that the images on the documents look as much like themselves as possible. Even working criminals: you can't use a driver's license to cash forged checks if the picture looks like someone else. All such images are made on application of the person whose image they bear and are created, at least in part, for the convenience or need of that person.

Prisoner identification photographs differ from nearly all other identification photographs in that they are made entirely for the convenience and use of the agencies taking the picture and creating the imprisonment: the police at time of arrest, the jailer at the prison. Police use mugshots as part of the record of arrest and as part of

3 "Henry Kissinger's Portrait," online at http://www.richardavedon.com/data/web/richard_avedon_ kissinger.pdf (accessed August 5, 2008).

4 "An Interview with Richard Avedon," by Nicole Wisniak, in *Egoïste* (September 1984). Reprinted in *Black & White* (Yale University, Spring 1986), pp. 8, 26–31. Online at http://www.richardavedon.com/ data/web/richard_avedon_egoiste.pdf (accessed August 5, 2008).

the information on wanted posters, and prison officials use identification photos to be sure the person described in the papers in an official file and the person locked up in a particular cell are one and the same. Sometimes officials do it just for their own delight or to document their own activities, such as the Khmer Rouge in Cambodia, which took identification photographs of prisoners about to be executed at S-21 prison in Phnom Penh because they wanted a visual record of the thousands of men, women, and children they murdered there.[5] And sometimes, like the SS officials who photographed everyone in their death camps, they do it because they are people who compulsively and scrupulously document everything.

The people in police and prisoner identification photographs do not want to be where they are; they do not want to be in the custody of the people who are taking and using the photographs; and they will never have the opportunity to use those photographs for their own purposes. Whereas most, if not all, people having their portrait done, in whatever medium, have an interest in the portrait representing them in a certain way ("I want it to make me beautiful," "I want it to show the real me," "I want it to look exactly like me," "I don't want it to misrepresent me"), the prisoner has no interest at all in the outcome of the photographic encounter, unless, perhaps, he or she is planning an escape and wants it to look as much unlike himself or herself as possible.

43

5 Online at www.tuolsleng.com/photographs.php (accessed August 5, 2008).

7
SEEING PEOPLE

IT ISN'T COLLECTIONS of police mugshots that come to mind when I look at the restored and enlarged prints of the photographs I took from that Cummins prison drawer in 1975. Rather it is the faces I find in Richard Avedon's *Portraits* and *In the American West*,[1] and in Paul Strand's *Tir a'Mhurain: Outer Hebrides*.[2] It is the hundreds of individuals presenting themselves to the camera of August Sander in his epic *People of the 20th Century* (seven volumes in the American edition[3]), and those photographed by the American photographer Milton Rogovin, whose camera gaze is very similar to Sander's, particularly in his triptychs—straight-on portraits of the same individuals in the 1970s, 1980s, and early 1990s[4]—and photographs of miners in the United States, South America, and Europe.[5]

ONE BIG SELF

I also think about the most elegant book of prison portraits ever published, a book about as far from this one in conception and presentation as you could get: Deborah Luster and C. D. Wright's *One Big Self: Prisoners of Louisiana*.[6] The prisoners in Luster's photos elegantly pose themselves, most of them against black backgrounds. The yellow images are printed with rounded corners, usually two to a page. The photos are

1 New York: Harry N. Abrams, 2002; New York: Harry N. Abrams, 2005.

2 New York: Grossman, 1968.

3 New York: Harry N. Abrams, 2002.

4 Milton Rogovin, *Triptychs: Buffalo's Lower West Side Revisited* (New York: Norton, 1982); online at http://www.loc.gov/rr/print/coll/238_rogo-triptychs.html (accessed August 5, 2008).

5 Milton Rogovin, *The Mining Photographs* (Los Angeles: Getty Trust, 2005).

6 Santa Fe: Twin Palms, 2003. Some of Luster's images are online at http://www.brown.edu/Facilities/David_Winton_Bell_Gallery/luster.html (accessed August 5, 2008).

punctuated by Wright's text, which consists of found lines from a variety of sources and her own poems inspired by those lines and the images.

Most, but not all, of the men and women in Luster's portraits look directly into the camera. One man kneels, with his elbows on a small round table covered with a black cloth; he looks upwards and to the right, and his palms touch in a position of prayer. A woman prisoner wears a rabbit suit that completely covers her body, hands and head; her white mittens hold a card below the cartoon rabbit face with her name in black ink. Many of the men display their bodies: Angola has more lifers than any other prison in America and there's not much to do there, so a lot of the men lift weights and get tattoos. One man has tattooed dots on his forehead where his eyebrows used to be and under his right eye; the inside of his lower lip, which he bends for the camera to see, is tattooed "fuck you." Another inmate faces away from the camera; all we see is the back of his shaved head, his white t-shirt and a large moth on his right shoulder.

Luster, whose mother was a murder victim, writes in her introduction:

> I cannot explain the need I felt to produce these portraits, because I do not fully understand it myself. I only know that it has something to do with the formal quality of loss and the way we cannot speak directly to those who have gone—how to touch the disappeared. I cannot explain my need to produce these portraits in such numbers except to say that I needed an aesthetic equivalent to the endless and indirect formality of loss. I also needed rules to support my intentions and to keep from being trapped by them. ...
>
> We are all creatures of chance and choice. I chose to photograph each person as they presented their very own selves before my camera on the chance that I might be fortunate enough to contact, as poet Jack Gilbert writes, "their hearts in their marvelous cases." I took my chances. I wanted this to be as collaborative an enterprise as possible.
>
> Each person photographed received an average of ten to fifteen wallet-sized prints. I have returned over twenty-five thousand prints to inmates. ...
>
> The final portraits, like my family's photographs, are small enough to be held in the hand—five by four inches. They are printed on prepared

45

black aluminum. Information supplied by the inmates is etched on the back of each plate and these plates are housed, loose, in a large black steel cabinet. To find the plates the viewer must pull open the heavy steel drawer that holds them. The plates may then be held and read or arranged on the cabinet top. [n.p.]

MIKE DISFARMER

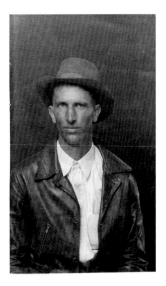 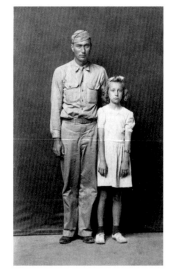

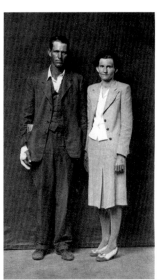 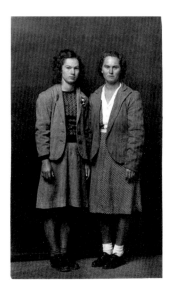

More than anything else, the Cummins prison portraits evoke what is perhaps the most austere body of portraits from a single community: the thousands of portraits the man who called himself Mike Disfarmer did in Heber Springs, Arkansas, in the first half of the twentieth century

The first collection of Disfarmer's portraits was published in 1976: Julia Scully's *Disfarmer: The Heber Springs Portraits, 1939–1946.*[7] The same year, the International Center of Photography in New York mounted the first public exhibit of Disfarmer's work. In 2005, there were three published collections: *Disfarmer: The Vintage Prints*, edited by Edwynn Houk, Gerd Sander, Richard B. Woodward, and Michael P. Matties;[8] *Original Disfarmer Photographs*, edited by Steven Kasher, with a long essay by historian Alan Trachtenberg;[9] and a second edition of the Scully book.[10] Disfarmer was born in 1884. His real name was Meyers, and he was the sixth of seven children in a German immigrant farming family. Meier is a German word for "dairy farmer." Mike Meyers was determined not to be a farmer of any kind, in fact or in name, so he taught himself photography and set up shop on his mother's back porch in 1915 or so. In 1939, he made up a new name for himself so people would know the thing he was not: he was forever after "Mike Disfarmer." He never married, seems to have had no friends, and left no trace of his presence on this earth except the four thousand 3.5" × 5.5" glass photographic plates, and the prints in countless family albums, which survive not only him, but most of his subjects as well.

He continued taking portraits until his death in 1959. Disfarmer's sessions often lasted an hour. People who remember him say he didn't talk much, if at all, and that he waited for the light to get right or for the sitters to get right. He may not have told his subjects how to pose, but he was the one who waited until this moment and not that one to fire the shutter. It's no accident that so many of the pictures look the way they do. As Willem de Kooning said to a proud father who showed him his kid's painting and asked if the painting wasn't the work of an artist: "An artist can do it twice." Disfarmer could do it twice, and again, and again.

Some of Disfarmer's subjects have a slight smile, most are nearly neutral, standing against a wall or against a dark grey cloth in their overalls or Sunday best. A few earlier pictures are against a cloth with some kind of classical motif, with the floor covered by a small patterned rug. In one photo, two men grin at one another, a bottle of whisky

47

7 Danbury, NH: Addison House, 1976.

8 New York: Edwynn Houk Gallery and powerHouse Books, 2005. Many Disfarmer images are online at http://disfarmer.org (accessed August 5, 2008).

9 Göttingen, Germany, and New York: Steidl/Steven Kasher Gallery, 2005. In his essay, "American Metamorphosis: Disfarmer and the Art of Studio Photography," included in that volume, Richard B. Woodward tells what little is known of Disfarmer's life and describes the series of fortunate steps by which the 4,000 negatives were found and preserved.

10 Santa Fe: Twin Palms Press, 2005.

on the floor between them. Some people sit on a small table. Some of the portraits are against a white wall with a dark piece of vertical lath and baseboard. A young man in football garb, including shoulder pads and helmet, poses in the classic three-point crouch, his left hand on his left knee, his right hand on the floor; in another photograph, two young men in similar attire pose in the same position. A grinning farmer in overalls, leather jacket, and black hat embraces his two dogs. A man and a boy look into the camera, in front of them on the bench an eight-point buck, freshly dead. A man holds an enormous fish that hangs from a short piece of line running through its mouth and gills; the fish's tail is not much above the man's ankles, its mouth not much below his chin. A woman poses in a long-sleeve silk blouse, ankle-length grass skirt, white shoes. In some of the family pictures, the little kids stand on the table so their heads are at the same level as their parents' The table appears again in a photo of two sisters, one about ten, the other about five, both in skirts held up by suspenders; the older one stands, the younger sits on the table. A woman in her twenties sits behind the same table, like the schoolteacher she probably was. Two women in dresses brace an older man in bibbed overalls and plaid shirt. They each have a hand on one of his shoulders. His right leg is rolled up revealing a wooden peg leg.

Other than the table, the only props are the ones they bring: the dead buck, the football helmet, the bottle of whiskey, the musical instruments, the huge fish. Disfarmer never gets closer than a medium close-up: from the waist or mid-chest up. He never shoots wider than necessary to get everybody into the frame. Most of the images are straight on, a few half-turned. The boys and girls, the men and women, the couples, the families often have arms around one another or intertwined.

I look at Sander's and Rogovin's portraits and feel deep rapport; I look at Luster's and sense a close collaboration of two people each working out their own private hell at the same time in the same place, using the same frame. With Disfarmer, it's more like someone who agrees to set up the conditions in which a photo will be made, but the key choices are all made by the subject: you want to dress in a football suit, okay, dress in a football suit; you want to bring a dead animal, okay, bring a dead animal. Hold it. Click. Disfarmer's portraits makes Walker Evans's Hale county portraits for *Let Us Now Praise Famous Men*[11] look warm and cozy.

"Who was this photographer," asks Scully, "who had portrayed his sitters with such clarity, immediacy, and above all tenderness, and who had so absented himself from the picture that I was aware only of the person standing before the camera?"[12]

11 James Agee and Walker Evans, *Let Us Now Praise Famous Men* (Boston: Houghton-Mifflin, 1941).

12 Santa Fe: Twin Palms Press, 2005, 176.

"Disfarmer depicts them as they are," writes historian Alan Trachtenberg in his essay in the Kasher volume. "He doesn't require that they deposit their everyday selves at the door. They present themselves masked only in the faces they know to be themselves; they are, in August Sander's great words, people without masks."[13] Narrative is at most implied, and the work of finding it is ours: "In an art of such impersonality and detachment, it is astonishing how much the hidden figure of the artist leaves his mark, makes his enigmatic presence felt. Yet it is the characters he gives us to know who initially attack our own defenses, who tempt us to translate appearances into words, to infer states of mind or life stories from what we see."[14]

Kasher is, in his introduction, even more explicit about our collaboration: "We gaze at these souls, honest faced and dressed for action. We learn something through an encounter. We look at them and are enlarged. The characters enacted by the souls of Heber Springs reflect back facets of ourselves."[15] Which is to say, if we really let ourselves look at them, they are not only images of others, but mirrors.

MAKING PORTRAITS

What in the prison portraits in this book makes up for the sophisticated technique, dedication to task, cool isolation, and independence of Mike Disfarmer? Maybe the simple fact that the prison photographers, like Disfarmer, were there, that they and the subjects were in the same place, and that the photographers, perhaps, understood more about where they now were than the sitters did, unless they were repeat offenders coming back for another round, in which case they were siblings.

The individuals who came to Mike Disfarmer for a portrait on the occasion of a birth, wedding, birthday, anniversary, graduation, or successful hunt were all there to celebrate and document a moment. But Disfarmer saw it all, beginning to end, birth to death. He knew where they came from and he knew where they were going and he knew that the photographs he was taking of them were simply points along that ineluctable path.

These prison photographers might have been naïve about the wider complexities of photographic process, but, like Mike Disfarmer, they weren't the least bit naïve about the existential situation in which their sitters were now located. The chair in which their subjects sat may have been on marks or bolted to the floor, and the camera position and lighting may have been fixed, but those photographers had total control of the one thing all photographers control: the decision of which moment to fire the shutter, the specific moment in which time will be forever stopped.

49

13 Ibid., 12.

14 Ibid., 19.

15 Ibid., 6.

8
THE ORDER OF THINGS

INITIALLY, THESE PHOTOGRAPHS, like all identification photographs, were instrumental and utilitarian. They were taken not so an institution or person could have something, as a photo in a museum collection or a memento of a moment in time, but to do something, to provide an aid to identification of specific individuals inside and outside of prison. At some level, everything manufactured by humans is instrumental and utilitarian, but some things do it at a level far closer to or actually on the surface, and these photographs are of that order of instrumentality and utility. They are exactly what they seem: part of the system of control.

But two things interrupted that instrumentality. The first was whatever separated those photographs from their dossiers, whatever events or decisions or choices resulted in their being in that Cummins prison drawer in 1975. The second was time: thirty-five to sixty years between the moment the photographs were made and the moment that convict clerk said to me, "This will interest you," and opened that drawer, and nearly thirty-five years more before the first readers of this book get to see them restored and enlarged here. The youngest person in these photos would now be at least ninety years old.

These images entered their canon coincidentally. Other than the forces that determined how many people of whatever gender, race, and class were sent to that prison each month and each year, the only determinant, from the prison's point of view, is external, serial, paratactic: this, then this, then this.

There is no typology, no hierarchy, and there never was. There is none of August Sander's attempt to show a sample of what he thought was one each of every category of person, none of Milton Rogovin's attempt to document workers in a trade or a neighborhood over time, none of Deborah Luster's attempt to demonstrate pride in highly stylized elegance. The only order of the original images was the order of seriality, which is after the fact, based entirely on decisions made by other people, by external agencies: the police, the prosecutors, and the courts. The order of photographs in the prison canon is based on who came in the door when , nothing

else. The body of portraiture they are closest to are those in the penny photographer's window in Walker Evans's photograph and in the images of someone like Heber Springs, Arkansas, town photographer, Mike Disfarmer.

If there is an order, a logic, to the images that went into that penitentiary drawer, I do not know what it was, and I'm certain that the man who opened it and said "Help yourself" had no idea of structure to that drawer either. The pictures were, I would guess, put in there at random, by various hands at various times and for various reasons. The ones that wound up in my pocket were the ones I managed to grab before the guard came in and sat down with his cigarette. I'll never know if what went into my pocket was representative of what was in the drawer, let alone what was in the all the dossiers themselves.

I've grouped the images I rescued in seven sections—four of them of men, three of women. Nearly all the photographs of men have prison numbers on them, so the four groups of men's photographs follow one another in what I think is chronological sequence. A third of the women's photographs had neither numbers nor dates, so I could only guess at the placement of that third group in the sequence. The order of images within each of the seven groups was based on visual rather than temporal desiderata: I put on facing pages images from that group that seemed to talk to or argue with one another, and I arranged the sets of facing pages and picked the opening and closing images in each section in a way that seemed to make the most sense for that group of images. So the groups are, so far as I can tell, serial; the images within the groups are communal.

It isn't the kind of order of books in a library or files in a cabinet or even canned goods in the grocery store. It's an order grounded in feeling which is itself partly based on having spent a great deal of time in face-to-face working relationship with these images, and based as much on everything else I know about prison and images and on everything that ever happened to me. Which is to say, if you asked me, "Why did you put those two pictures on that verso and recto?" I might be able to give you what sounded like specific reasons, but the real reason is that's where they told me they wanted to be.

And in that regard, they are ordered the way most other things get ordered. There is probably order in certain workings of the universe (that is what keeps physicists and taxonomic biologists going), but for most things, order exists as we make or imagine

51

it. That is the point of Jorge Luis Borges' fabulous catalog of animals that Foucault quotes so delightfully at the beginning of *The Order of Things*:[1]

> This book first arose out of a passage in Borges, out of the laughter that shattered, as I read the passage, all the familiar landmarks of my thought—our thought, the thought that bears the stamp of our age and our geography—breaking up all the ordered surfaces and all the planes with which we are accustomed to tame the wild profusion of existing things, and continuing long afterwards to disturb and threaten with collapse our age-old distinction between the Same and the Other. This passage quotes a 'certain Chinese encyclopedia' in which it is written that 'animals are divided into: (a) belonging to the Emperor, (b) embalmed, (c) tame, (d) sucking pigs, (e) sirens, (f) fabulous, (g) stray dogs, (h) included in the present classification, (i) frenzied, (j) innumerable, (k) drawn with a very fine camelhair brush, (l) et cetera, (m) having just broken the water pitcher, (n) that from a long way off look like flies.' In the wonderment of this taxonomy, the thing we apprehend in one great leap, the thing that, by means of the fable, is demonstrated as the exotic charm of another system of thought, is the limitation of our own, the stark impossibility of thinking *that*.

The order we have here is the order we have here: these images, from that drawer, selected and edited by me, seen in this book by you. That is no more and no less than any other order. Of, say, things that do or do not have fur, or things that from a long way off look like flies. Or of, say, the faces you might have seen in the buildings or fields of that penitentiary in those years, and the faces you would see in those buildings and fields even now.

52

1 Which I think is far more eloquent in its anonymous 1970 Pantheon English-language translation than in Foucault's French (in *Les Mots et les choses*, Paris: Gallimard, 1966) or Borges' Spanish (in "El Idioma Analitico de John Wilkins," in *Otras inquisiciones*, Buneos Aires: Sur, 1952), or the English translation of that ("The Analytical Language of John Wilkins," in *Selected Non-Fictions*, New York: Viking, 1999).

9
MIRRORS

MAKING FACES

MOST PEOPLE ORGANIZE their face when they approach a mirror. They do it as unconsciously as they refocus their eyes when they look from an object near at hand to an object in the distance.

You can see this happen if you watch people who aren't aware you're watching them as they approach a mirror. You have seen yourself do it if you've come upon your face in a mirror unexpectedly in a taxi, looking out the front window, and your field of view includes a face that is at first not the least bit familiar and then suddenly is at once familiar but strange, and then the face recomposes itself and becomes the face you've been seeing in mirrors all your adult life.

Likewise for the camera. When most people are taking part in the making of a photograph of themselves (as opposed to when they're being photographed unawares or while they're too busy with what they're doing to pay attention to the photographer and the lens), they put on one of their camera faces. What are "camera faces"? Watch politicians as they walk down a corridor with their staff, and then turn the corner to the area where the press photographers are waiting. It is as if a switch had been thrown, redirecting all the facial muscles. Portrait and news photographers deal with this phenomenon all the time. "Don't smile for this one," they say, or "Just try to look normal now." Or they learn to chat someone up or catch them unawares so those muscles in service of the camera-face are relaxed or doing something else.

The Canadian portrait photographer Yousuf Karsh had a session in 1941 with British Prime Minister Winston Churchill. "No one had told Churchill of the session, so after lighting up a cigar he growled, 'Why was I not told of this?' Karsh then asked Churchill to remove the cigar for the photographic portrait. When Churchill refused, Karsh, then 33, walked up to the great man, said, 'Forgive me, sir,' and calmly snatched the cigar from Churchill's lips. As Churchill glowered at the

camera, Karsh snapped the picture."[1] Churchill and his cigars were world famous, but the most famous portrait of Churchill was, and remains, the one of him pissed-off because some young photographer had snatched his stogie.

I used the plural—"camera faces"—because people who are used to being photographed engage in the equivalent of "code switching" for different camera situations. "Code switching" is a term linguists have for the various ways a person uses language in different contexts: with a lover, employer, students, teachers, the police, a servant, a salesperson in an upscale store, a salesperson in a downscale store, a stranger on the street, a parent, a child, and so on. Without any need for conscious thought, we adopt different ways of speaking in each of these contexts.

Children have many camera faces; which one they wear at any moment depends, as it does for all of us, on the age and position of the person holding the camera. Watch them when they take pictures of one another, when they're being photographed by their parents or grandparents or a family friend, or for a school or team picture. Most people have a camera-face for official moments, like passport or driver's license or pistol permit photographs. If you stand in line at the motor vehicle office, you'll sometimes hear the photo clerk say, "Please don't smile." That is, "Put all the teeth away so you'll look natural. This photo is supposed to look like you, not the way you look when you're posing for a camera."

READING FACES

So what can we read in the face, in the eyes?

Greta Garbo's biographer, Barry Paris, describes the final shot of *Queen Christina* as "one of the most exquisite images in film history."[2] The camera zooms in on her face as she stands at the bow of a ship, shortly after the death of her lover. Film reviewers and critics have speculated at length on what thoughts and emotions occupied the character and Garbo at that astonishing filmic moment. The film's director, Rouben Mamoulian says that he told Garbo, "Just be completely passive, don't think about anything, express nothing, and preferably don't even blink your eyes. Just be a mask, and then the audience will write in whatever emotion they feel should be there. If you were to cry, some people will say, 'Ah, she's a small woman.' If you didn't cry, some would say, 'What's the matter with her? Her lover is dead.' If she smiles, they'll say 'she's crazy.' And so on. So that's what she did—she stood there, just a blank face but it happens to be GARBO's face. And each critic had his own interpretation.

54

1 CBC News, "Yousuf Karsh, 1908–2002" (July 2002), online at http://www.cbc.ca/news/obit/karsh/ (accessed May 29, 2007).

2 Barry Paris, *Garbo* (New York: Alfred A. Knopf, 1995), 304.

Everybody wrote his own ending—which is a valid principle in the theater and more so on the screen."[3]

Mamoulian was describing what filmmakers call the "Kuleshov Effect," named for Russian filmmaker Lev Kuleshov's famous montage experiment. About 1918, he intercut a shot of actor Ivan Mozzhukhin's face in which Mozzhukhin's expression never changed at all with preexisting shots of a plate of soup, a girl, and an old woman's coffin. Audiences who watched the edited film were astonished at Mozzhukhin's versatility—the way he expressed hunger, desire, and grief. But it was all the same shot of Mozzhukhin repeated three times.

We see images in context, and read them accordingly. If the caption under a photograph of an unknown face identifies it as the face of a Nobel Prize laureate in medicine we read the photograph one way; if the caption identifies the owner of the face as a child molester we read it another way. How could we do otherwise?

There is a book of arrest photographs that were made in 1907 and 1908 in the small town of Marysville, California, called *Prisoners*,[4] the first part of which consists of photographs with the subject's name and presumed offense written across the top; the second part is newspaper clippings about the crimes and dispositions. I look at the picture, see the crime, and think, "Yeah, he looks like a murderer all right," or, "He sure doesn't look like a rapist." Everything in *Prisoners* starts with that paired information, the words and the images. It would be the same even if those identifications were elsewhere in the book, with the newspaper clippings, say. Once I saw them I could never again look at that face without identifying it with that crime, that set of facts.[5]

In this book, I've said that these images were created to be part of jackets, the dossiers the prison keeps with all the printed information it possesses on each of its detainees, but I have said nothing about what the dossiers have to tell us about any of the individuals pictured here. I've written about the genre, I've speculated about the photographic moment, I've said things I know about prisons and about things I know from other regimes of knowledge, but nothing about what specific jackets might tell us about a prisoner with one of those numbers. Everything I have to say about these specific images—even the dating of them—is derived from looking at the images themselves.

55

3 Ibid., 306.

4 Arne Svenson, *Prisoners* (New York: Blast Books, 1997).

5 There is another, much more glamorous and very different, book about arrest mugshots, *Least Wanted: A Century of American Mugshots*, (New York and Göttingen: Stendl/Kasher, 2006), edited and designed by Mark Michaelson and Steven Kasher. It focuses primarily on arrest cards—with all the attendant notations, fingerprints, photographs, and such—as aesthetic objects.

It was a conscious choice, similar to one Diane Christian and I made when we did our book and film about condemned men in Texas.[6] We included no information about the specific crimes that got them there. We were documenting life on Death Row, not law enforcement or criminal trials or kinds of homicide in Texas. The given of the film and book was that everyone in both had been convicted of capital murder. The film and book themselves were about life in the community of the condemned. Could people on the outside have listened to the words if beneath the faces they saw text detailing the specific acts that got the speakers on the Row: this one killed his children, this one killed a policeman, this one killed and raped a woman and then ate part of her body?... Who could hear the words in the presence of such horrors? And what space would there be for any counterarguments? What place would there be for the man who, eleven years later, was exonerated by DNA evidence? No: the point of that film was life on the Row, not murders and certainly not murder trials. The murders and the murder trials took place before the men ever got on the Row, before our filming ever began; they were events that got us all there, but not what was going on in the presence of our cameras, sound recorders, and microphones.

There are names on only a few of the prints I found in that Cummins prison drawer, and no information of any kind on most of the women's images. No one at Cummins during my last visit in 1975 knew if the files from those years still existed or even where they might be stored. For a while I thought to try to enlist the aid of current correctional authorities, to see if perhaps the folders for the people whose faces are depicted here still exist somewhere. But then I found myself in the Death Row situation: how would you regard these eyes looking into yours if on the opposite page or below the image itself was text saying this man or woman had been convicted of this or that crime? Could you look at them in terms of the image itself, or would you read the face in terms of the dossier?

What I'm hoping to do here is to liberate these faces from the dossiers, not to reimprison them in them. They were already separated from the dossiers by the various people who put the photographs in that Cummins drawer. How could we possibly, at this distance of time, know what things in those dossiers are true or false, which statements should be mapped on the faces we see, and which are the creative results of the process that existed nearly a century ago? Why should we let the dossier speak and once again force the persons to stand mute?

For now, the images stand alone—archaeological links to lives in another place, another time. Save for one fact that is a given—everyone pictured here had been sent to prison—and what we find in or infer from the images themselves, we know

6 *Death Row*, Documentary Research, 1979; *Death Row* (Boston: Beacon Press, 1980).

nothing about these persons, and perhaps never shall. Someone might get into the Arkansas archive and find those dossiers and link this face with that report—but that would be a project very different from our enterprise here. It would be about what the dossiers said rather than what the eyes see. This is a book based on evidence from the past, and the evidence consists entirely of the images themselves. The meaning of that evidence is grounded in what each of us brings to our encounters with it.

A reader of an earlier version of this introduction suggested I discuss ways in which Susan Sontag's *On Photography* and Roland Barthes' *Camera Lucida*[7] inform the images in this book. I responded that I didn't see that the speculations of either of those writers on photography, however interesting they might be in their own right, had much moment here. On further thought, however, it occurs to me that Barthes' perhaps does, but with the signs reversed: as a perfect example and articulation of what this work is not. Barthes writes of the anguish he feels looking at photographs of his dead mother. The most interesting photograph for him is a site of nostalgia, a word that derives from the Greek *nostos*, homecoming, and *algos*, pain. My friend Warren Bennis once described it as "the memory of an incomplete experience." For Barthes, the photograph of the dead loved one invokes nostalgia because it can never be more than simulacrum of what has been irretrievably lost but remains active in memory, more so because of the specificity of the photographic image. His photograph is about absence, subtraction, a negative.[8]

There is no loss in the photographs you and I look at here, at least not for us. You never knew these men and women and neither did I. These photographs introduce into our awareness images and lives that were not previously part of our world but which now very well may be.

At the opening reception for an exhibit of a small group of the photographs in this book in Buffalo in 2004, several people who spoke to me about specific images

7 Susan Sontag, *On Photography* (New York: Anchor, 1977); Roland Barthes, *Camera Lucida: Reflections on Photography*, trans. Richard Howard (New York: Farrar, Straus and Giroux 1981); a translation of *La Chambre Claire* (Paris: Editions du Seuil, 1980).

8 Sontag, long-time companion of photographer Annie Liebowitz, knew a great deal about photography and was exquisitely sensitive to it. Barthes wrote about it, but he never took photographs himself and wasn't very good at looking at them. He writes, for example, of a photograph that "made me pause: the (photographic) banality of a rebellion in Nicaragua: a ruined street, two helmeted soldiers on patrol; behind them two nuns" (p. 23). The photograph he is writing about is on the facing page (p. 22). In it are two nuns and, between the nuns and the camera, three soldiers. How could Barthes have missed or why would he have ignored the third soldier? The key line in *Camera Lucida*, is, perhaps this one: "Ultimately—or at the limit—in order to see a photograph well, it is best to look away or close your eyes" (p. 53).

referred to the crime for which the person in this or that image was serving time. I'd say, "What are you talking about? There are no captions on any of those prints? I don't know what they were serving time for." They'd reply, "Yes, but that's what I thought when I looked at them."

Our thoughts and feelings, not the convicts' thoughts and experiences. We know the former only if we open our consciousness to them; we never know the latter at all. Of the convicts, we know only their faces.

Which is not inconsequential. The painter R. B. Kitaj wrote of coming across "this line from Wittgenstein: 'The face is the soul of the body...' I've always agreed with that sovereign face idea, for art. Above all, Cézanne: 'The goal of all art is the human face' (said to Vollard)."[9]

This is a book about and of images of the human face; it is not about criminal acts or criminal careers, and neither is it about prison and prison careers. The only given here, as I wrote earlier, is that the images are all of prisoners. For whatever reason, they were deprived of liberty, the enduring proof of which is the group of images reproduced on these pages you now hold. The conclusions we draw, the feelings we have, the narratives we suppose—they are all our own, based on our encounters with individual images and on the facts of our own lives, uninfluenced by accounts in dossiers that may or may not be correct in matters large and small. The images are, in that regard, mirrors, resonating with aspects of ourselves we perhaps never before encountered.

Most times we look in the mirror, we have our faces composed before we ever get there. What is special about these faces in which we meet some aspect of ourselves we have perhaps never seen before is we don't get a chance to compose it. It is there, waiting for us.

9 R. B. Kitaj, *Second Diasporist Manifesto (A New Kind of Long Poem in 615 Free Verses)* (New Haven: Yale, 2007), verse 33.

THE PORTRAITS

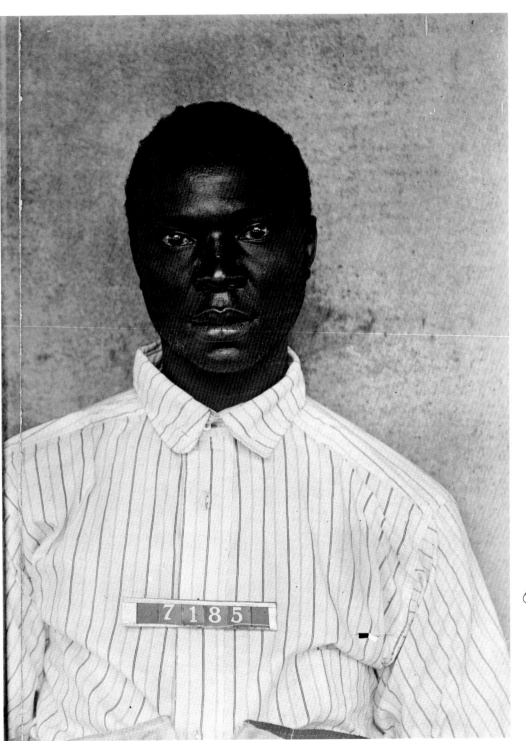

61

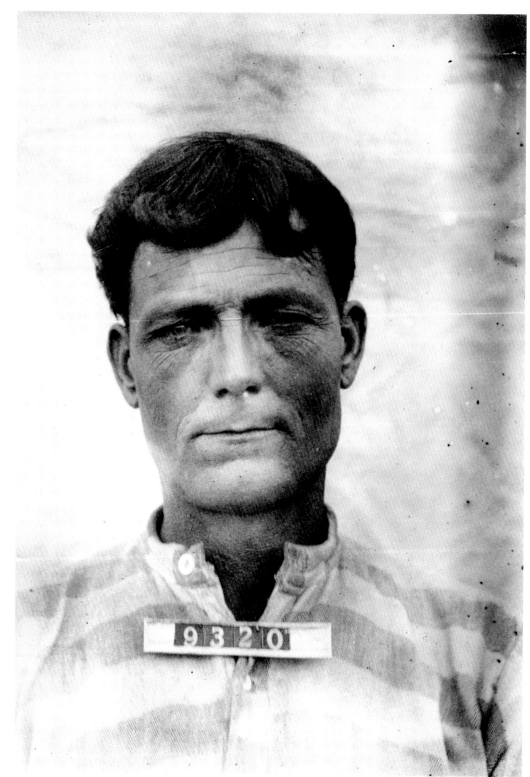

62

63

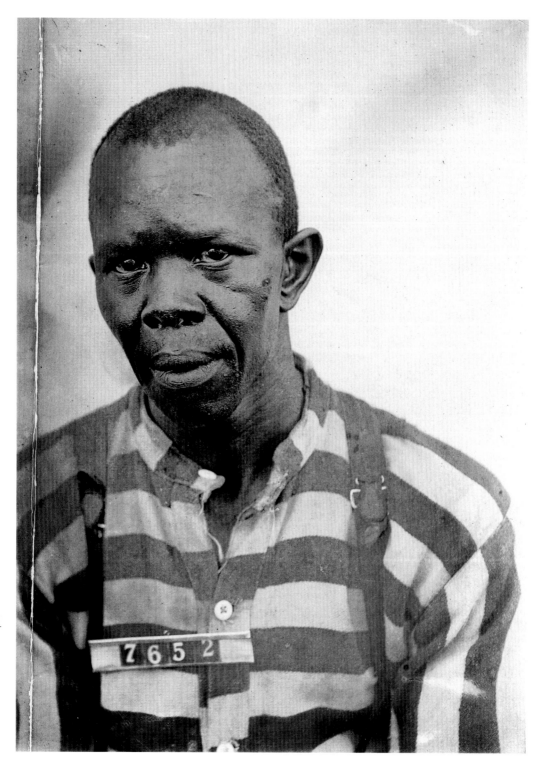

64

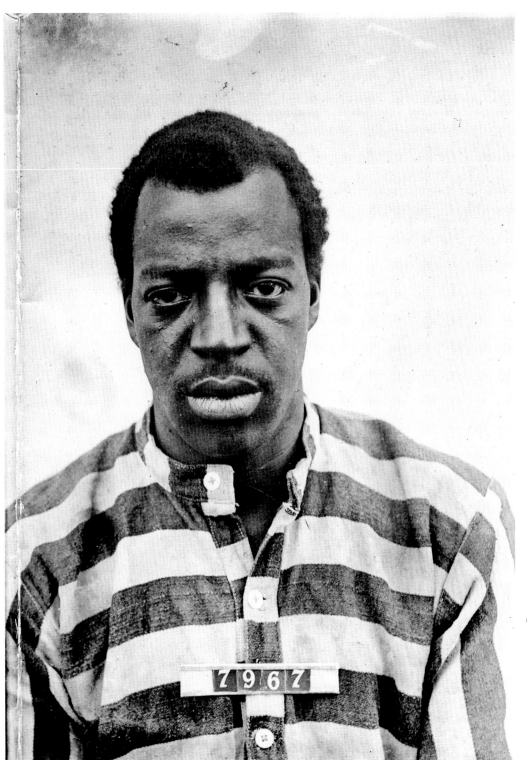

66

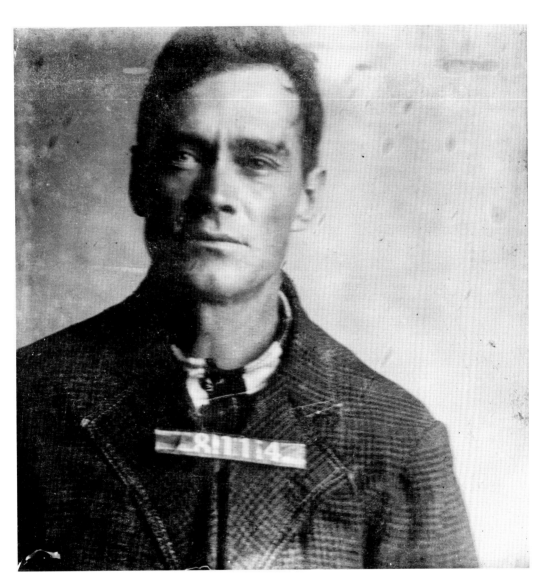

67

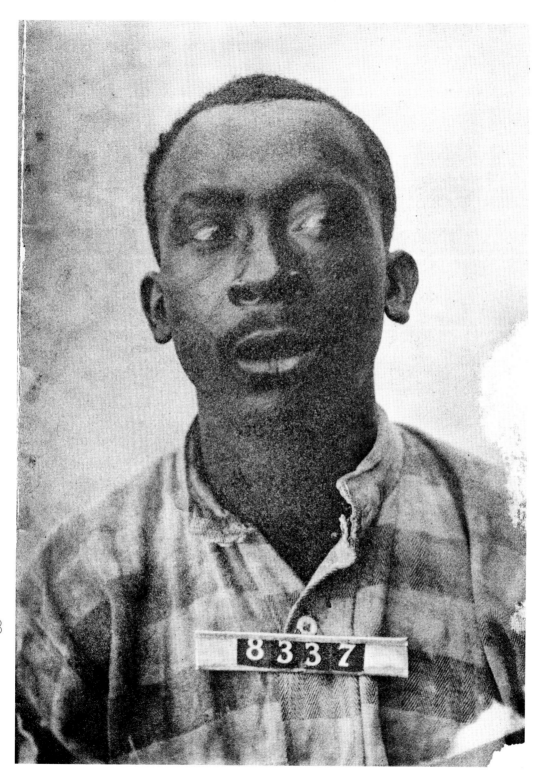

68

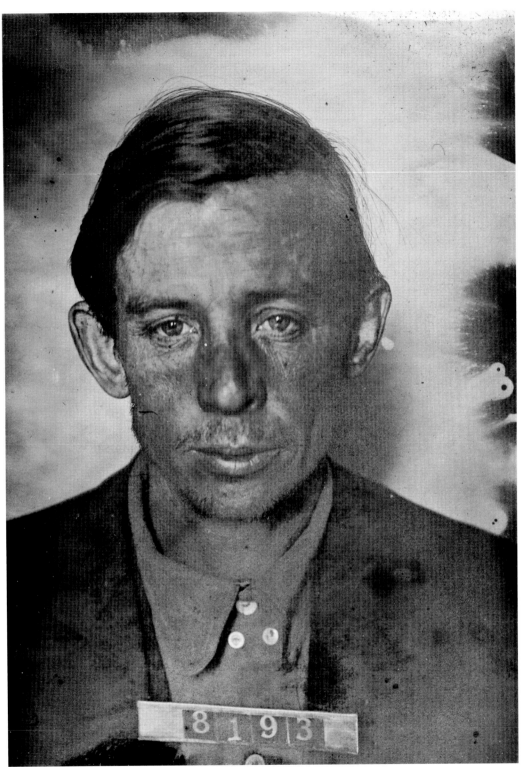

69

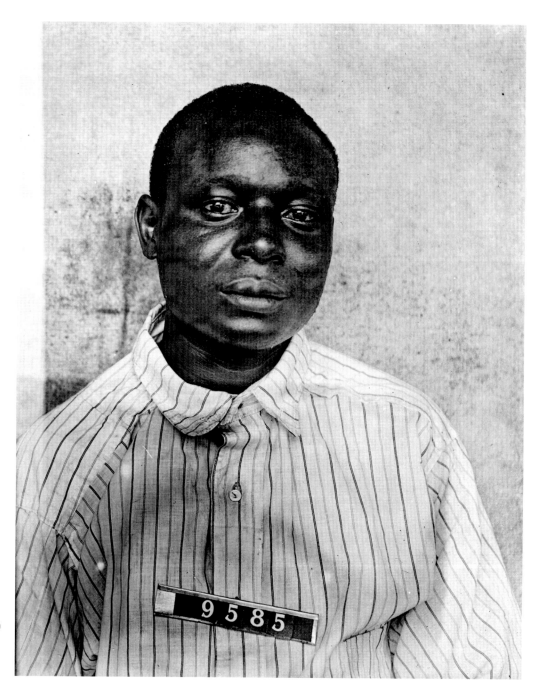

70

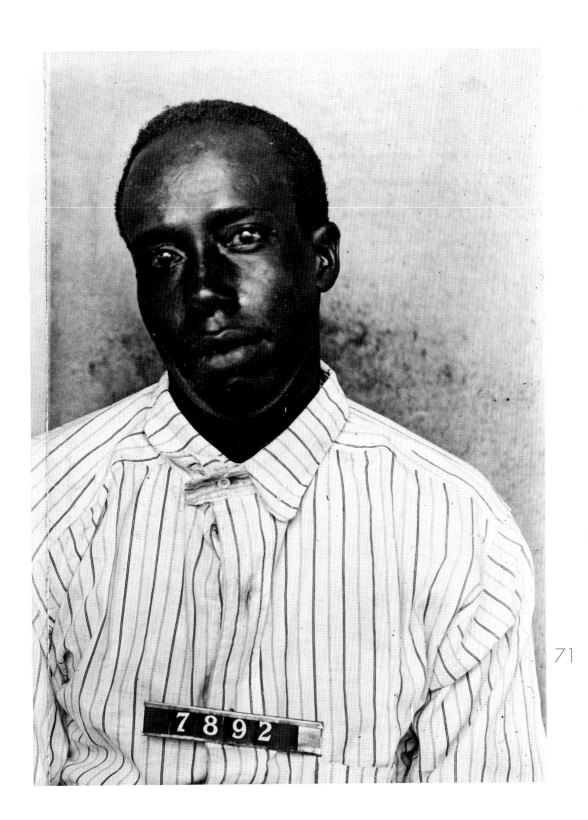

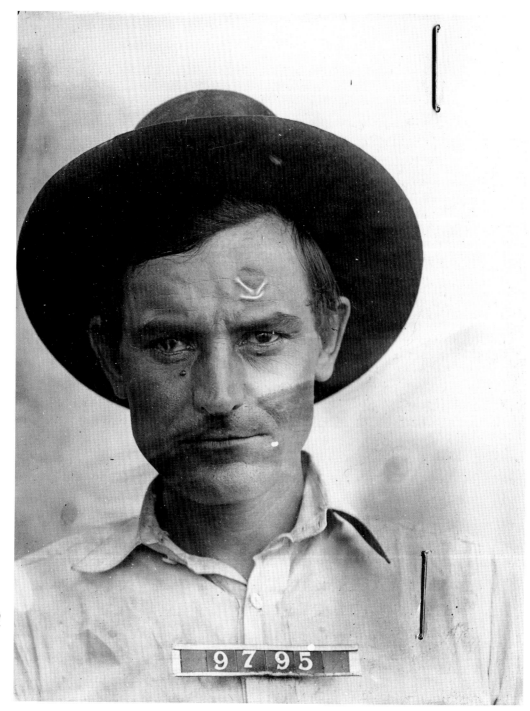

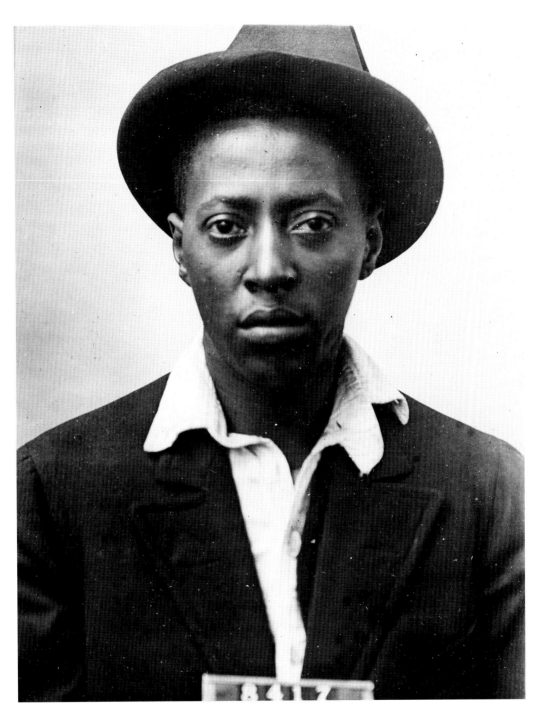

73

74

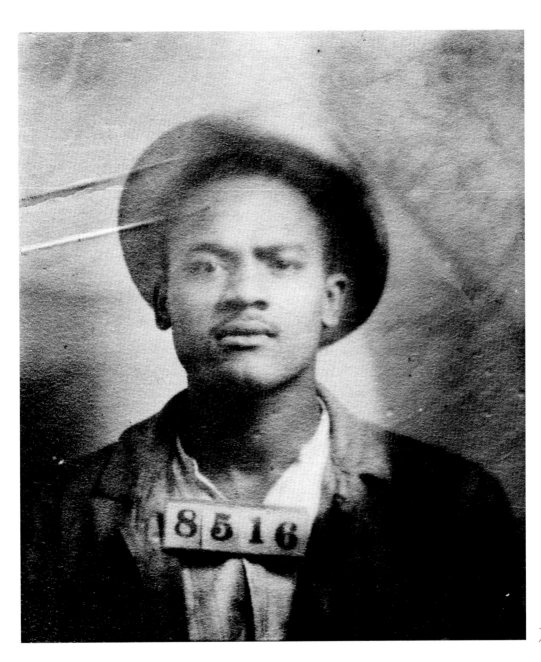

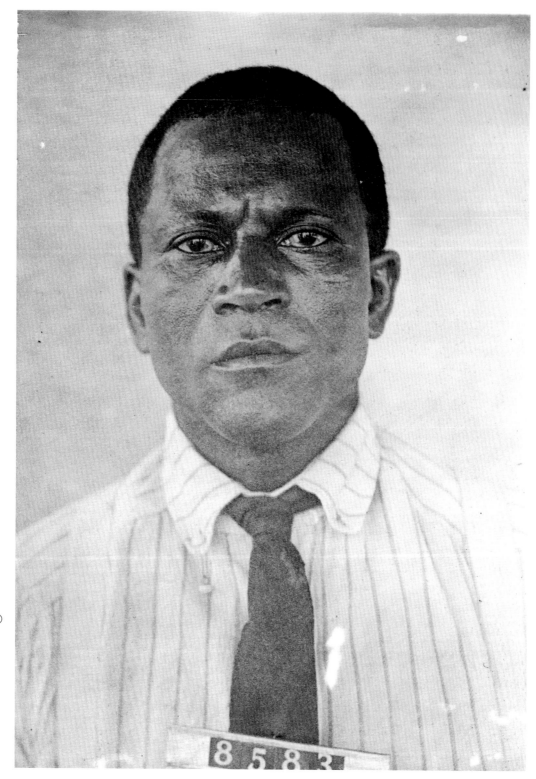

76

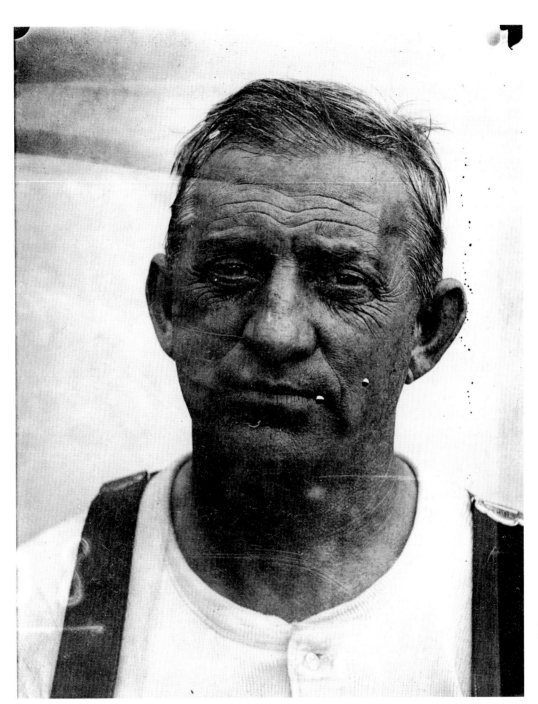

77

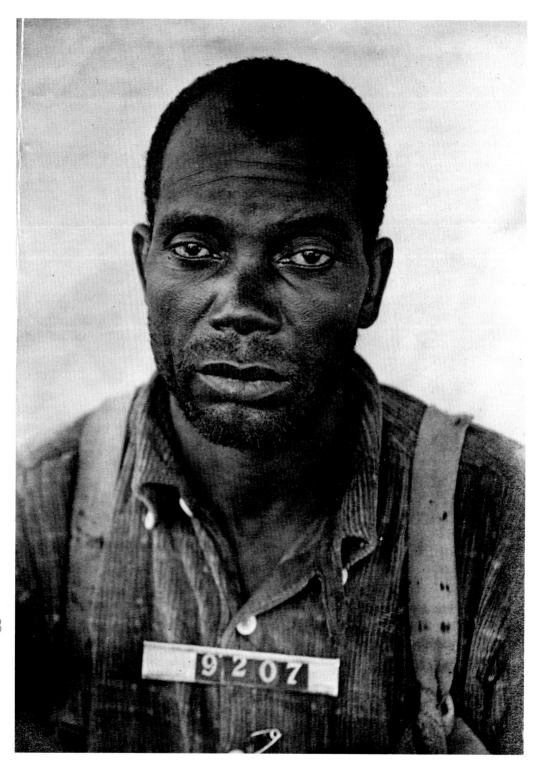

78

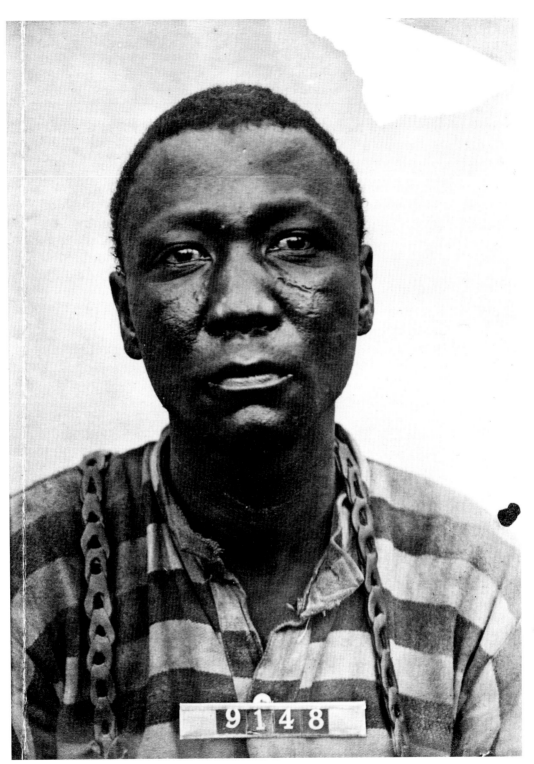

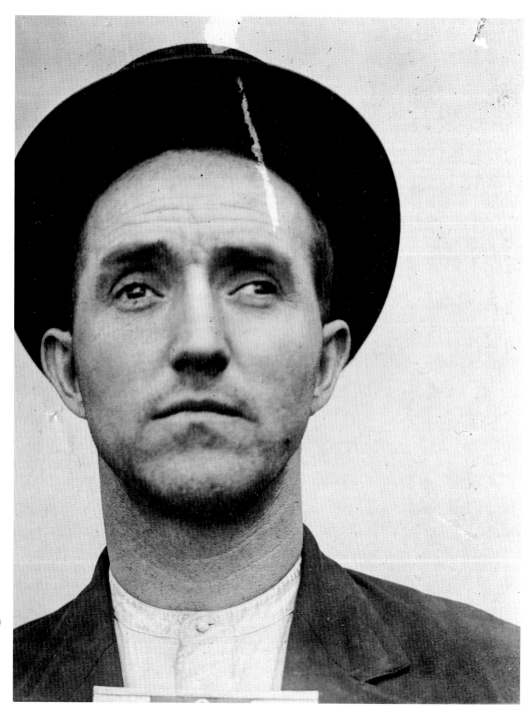

80

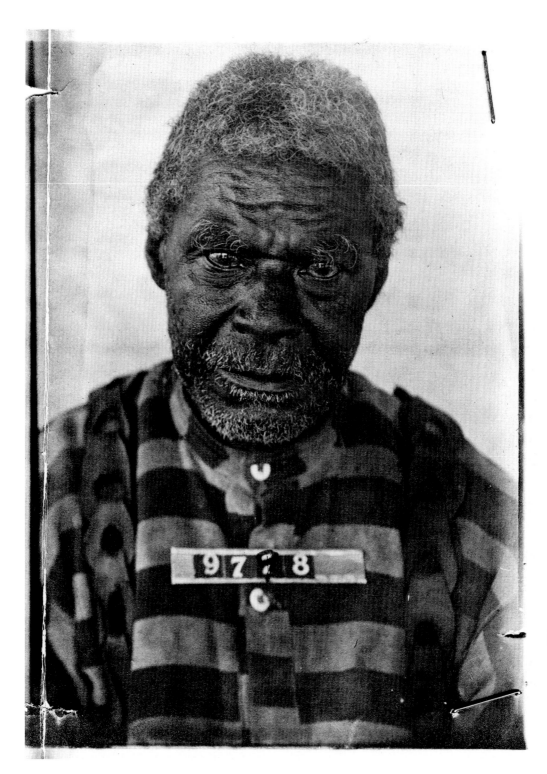

97 8

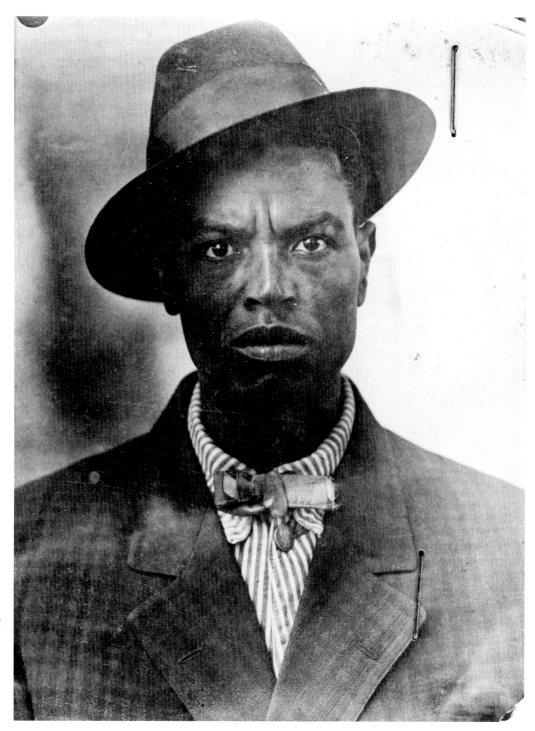

82

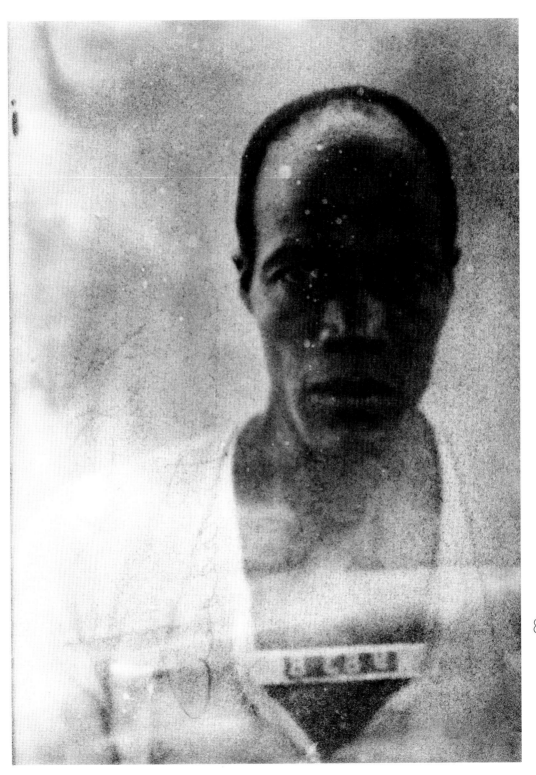

83

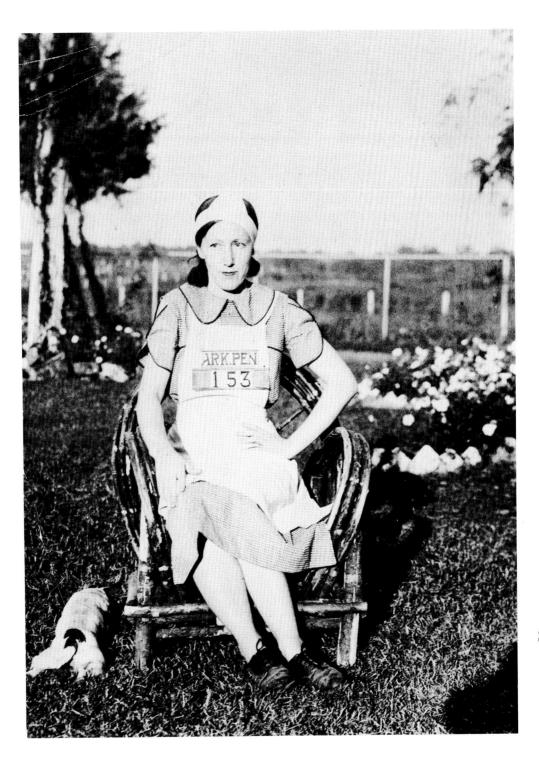

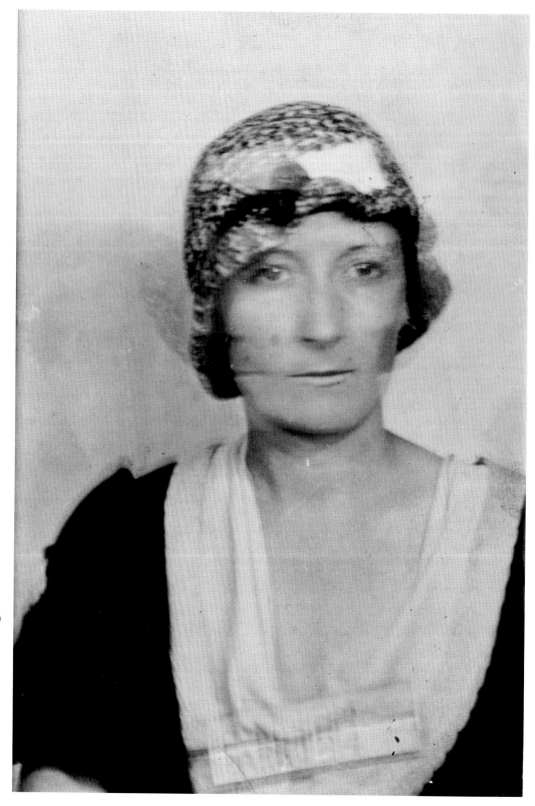

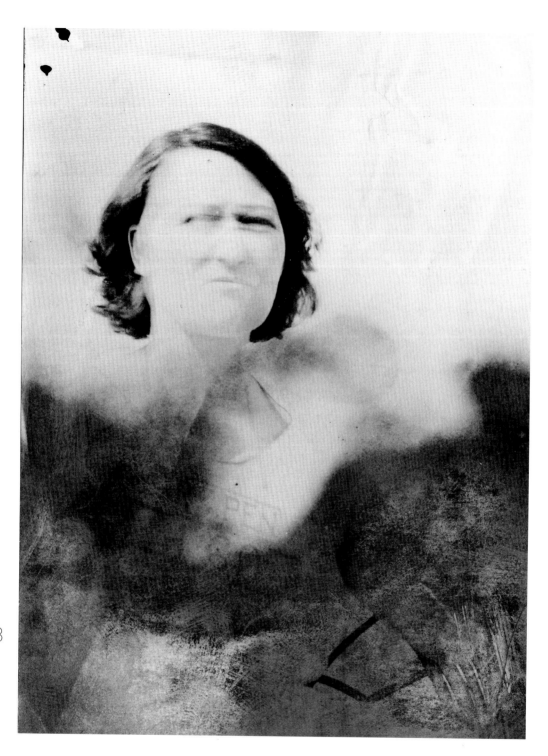

88

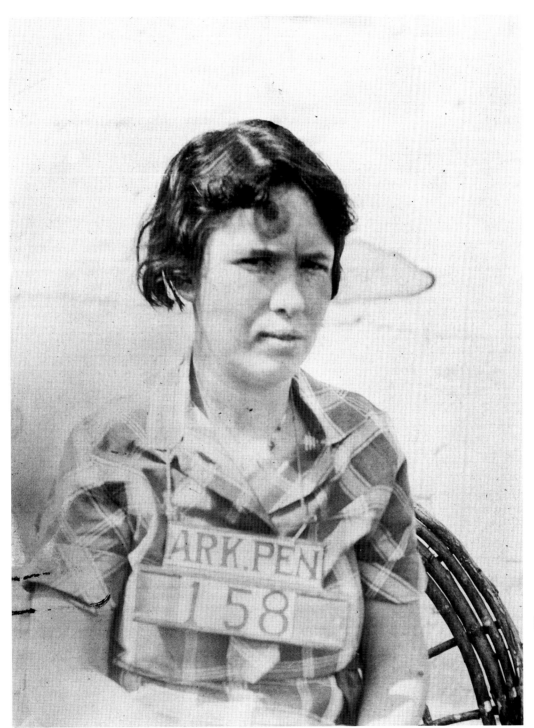

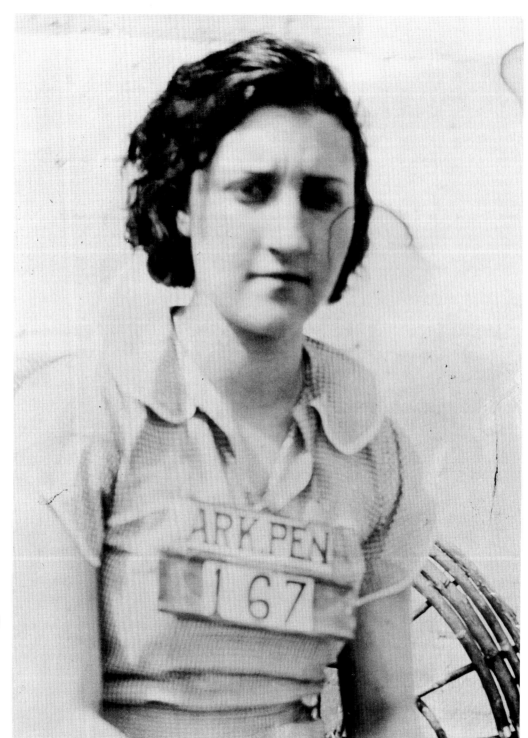

90

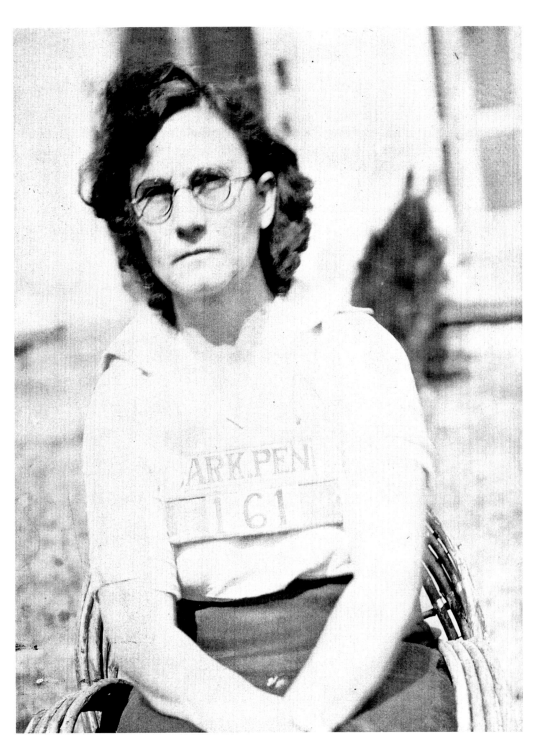

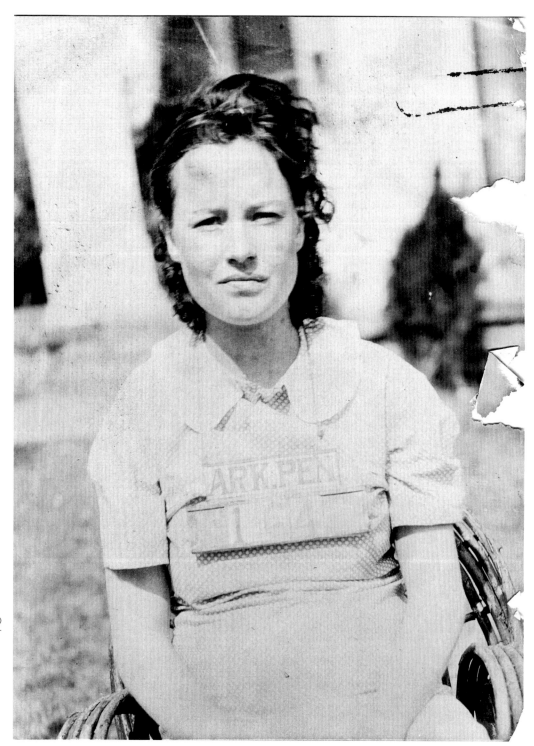

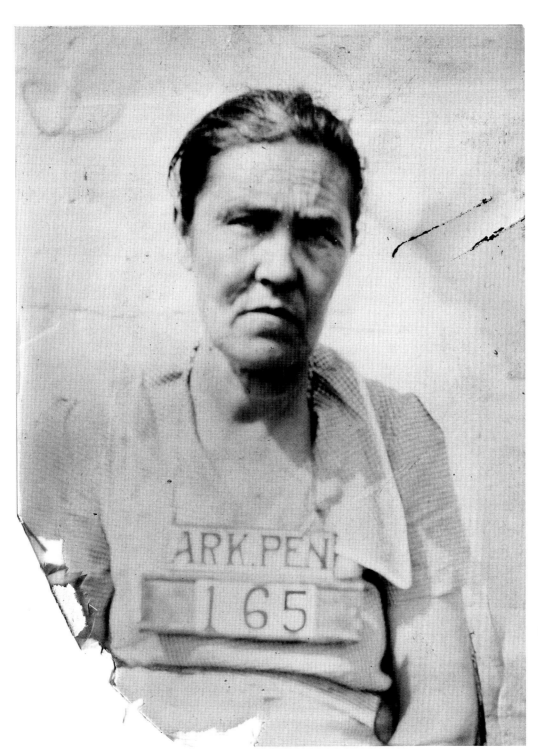

93

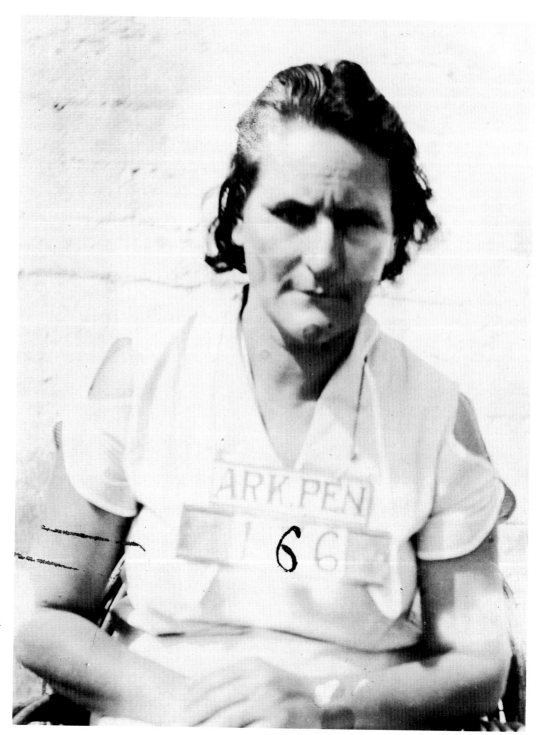

94

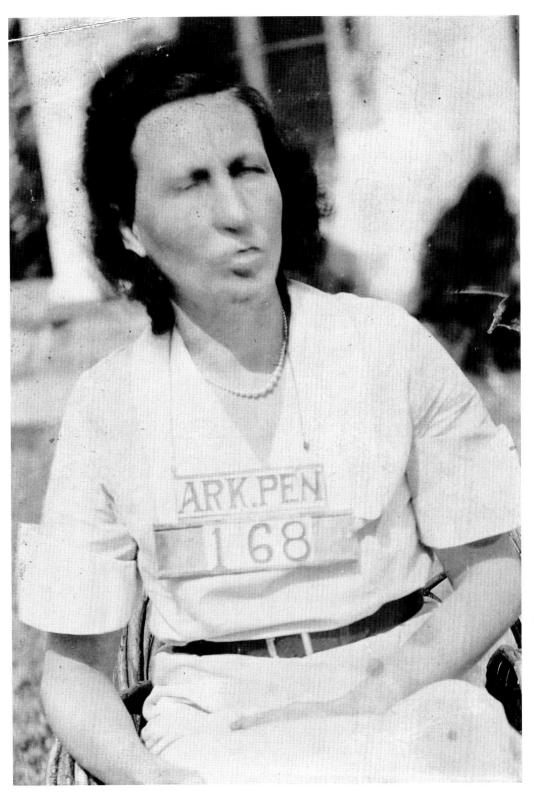

95

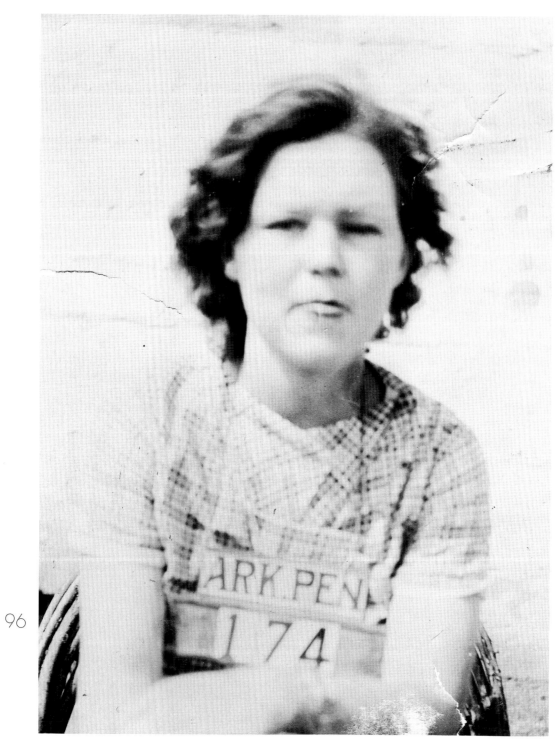

96

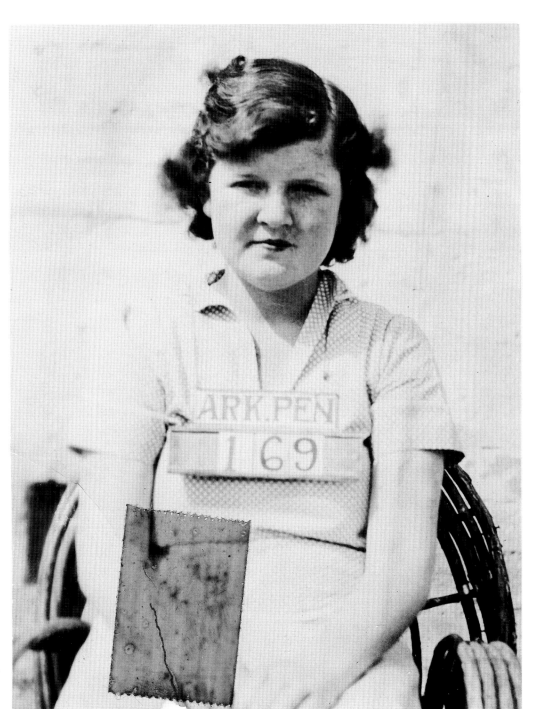

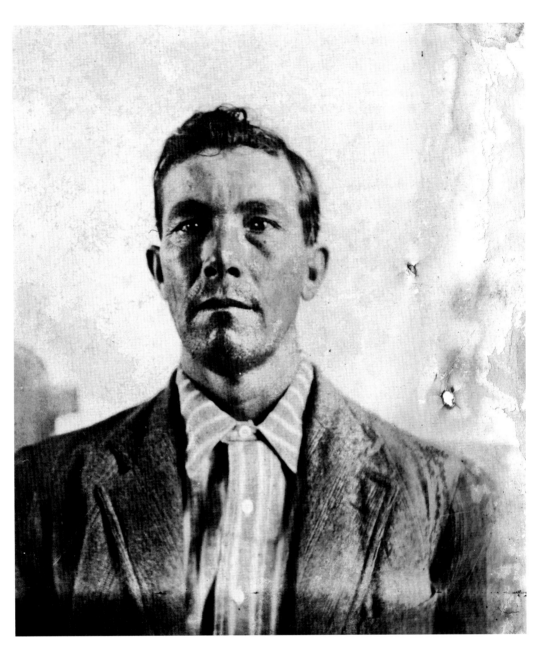

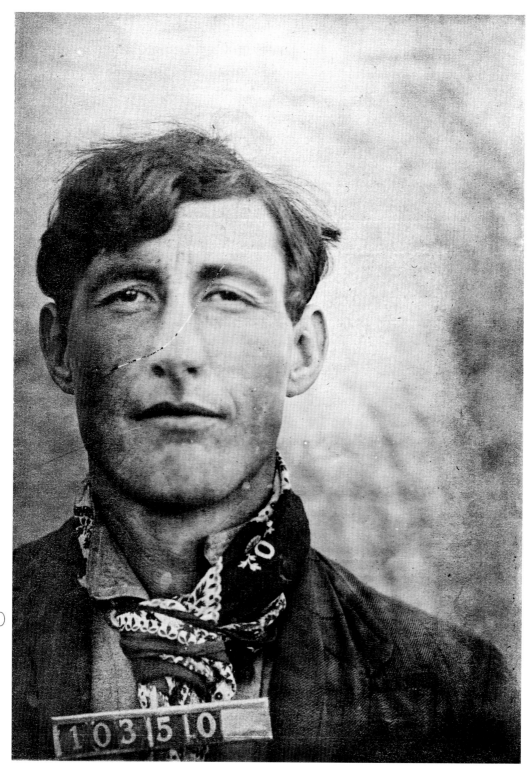

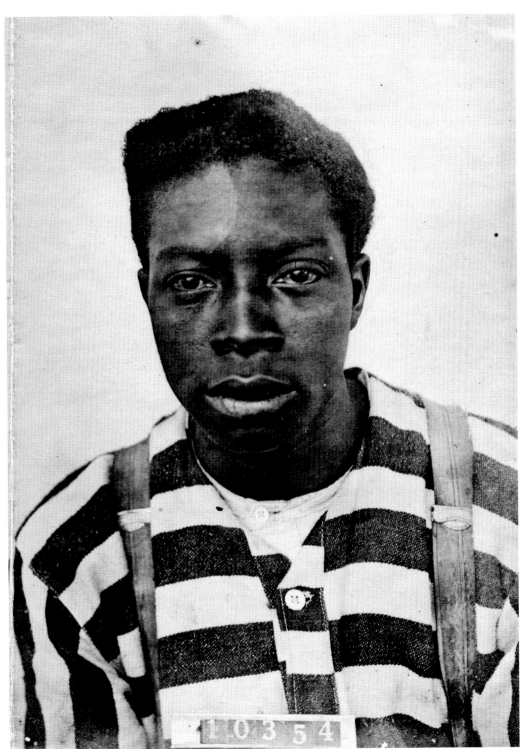

102

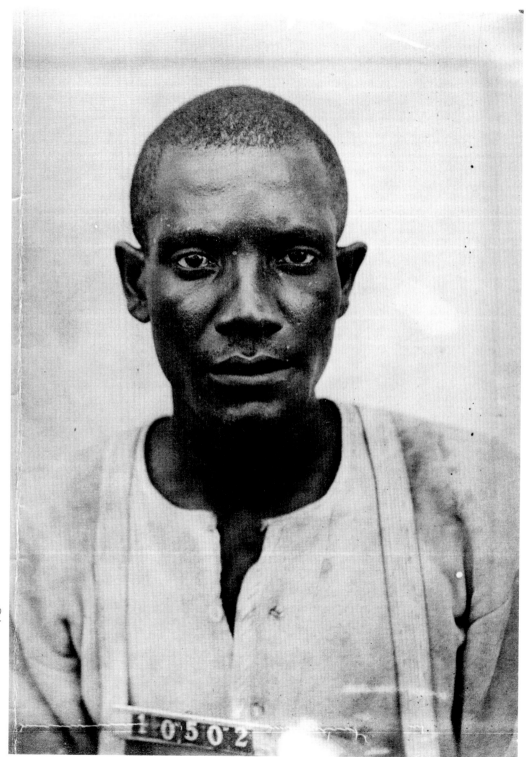

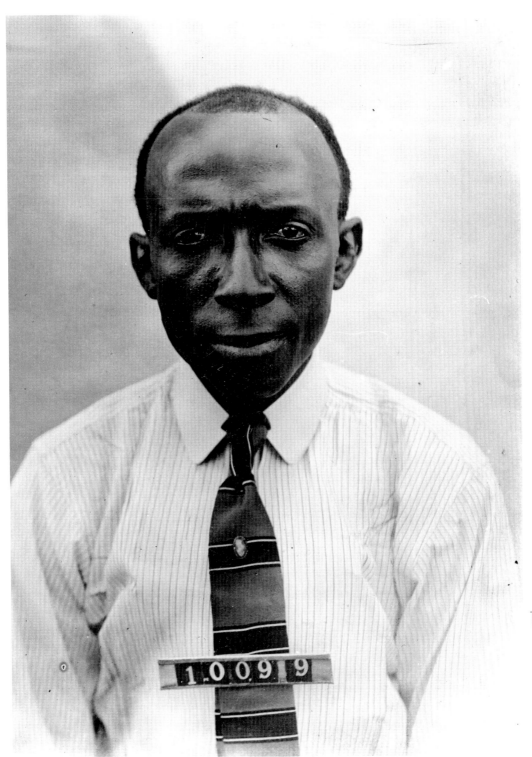

103

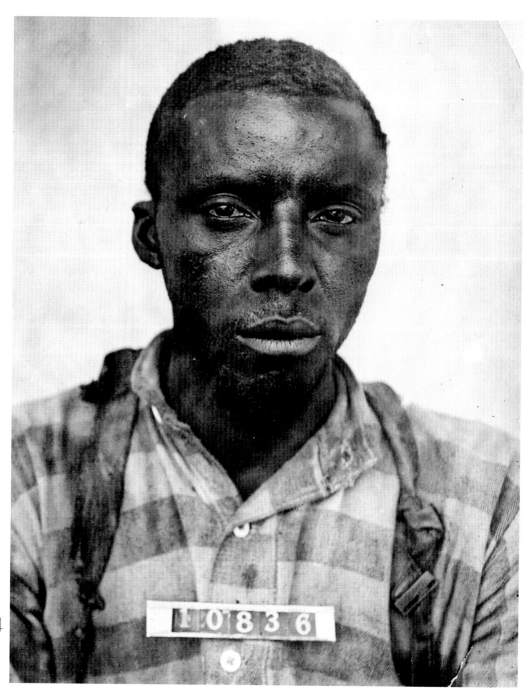

104

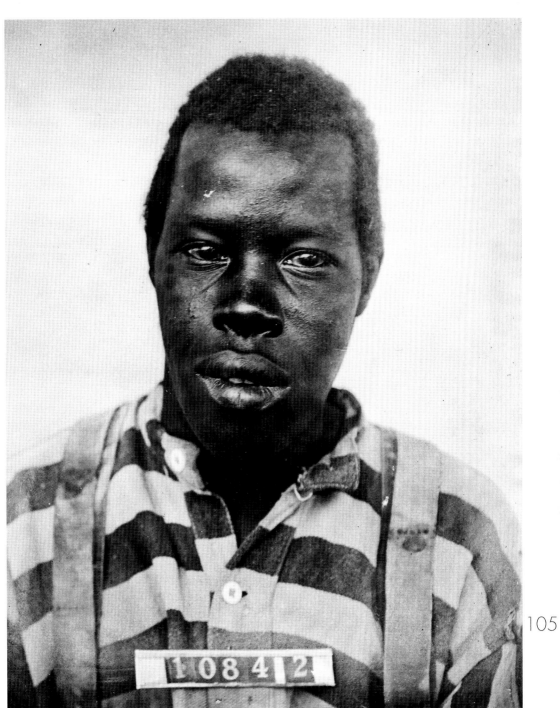

105

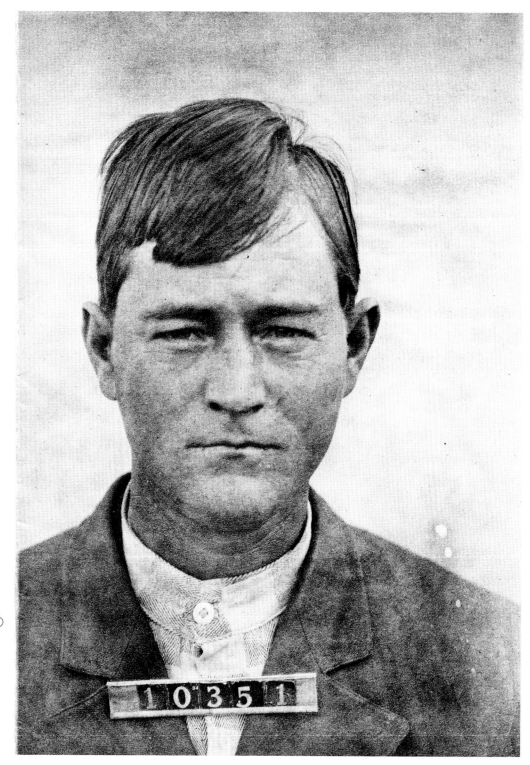

106

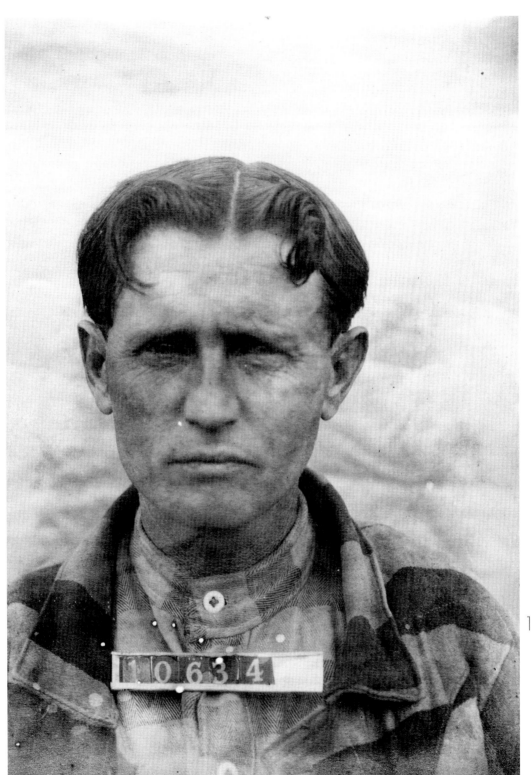

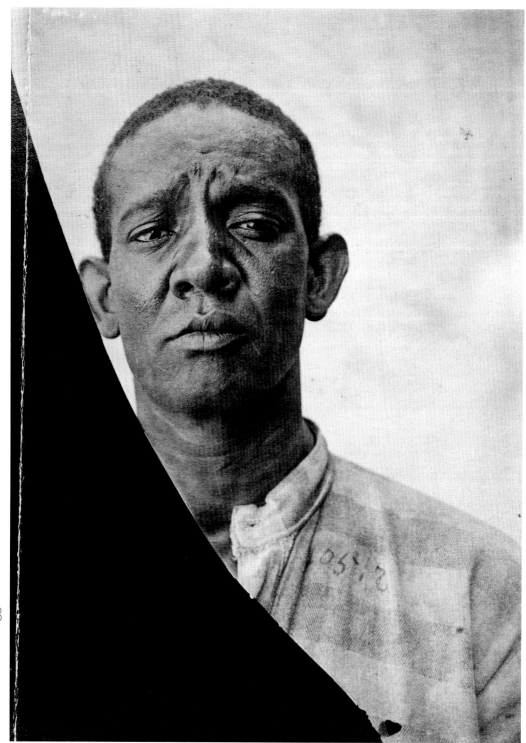

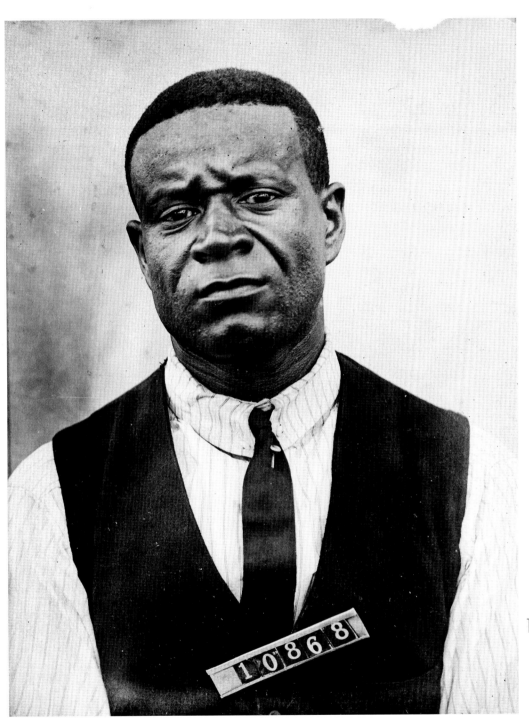

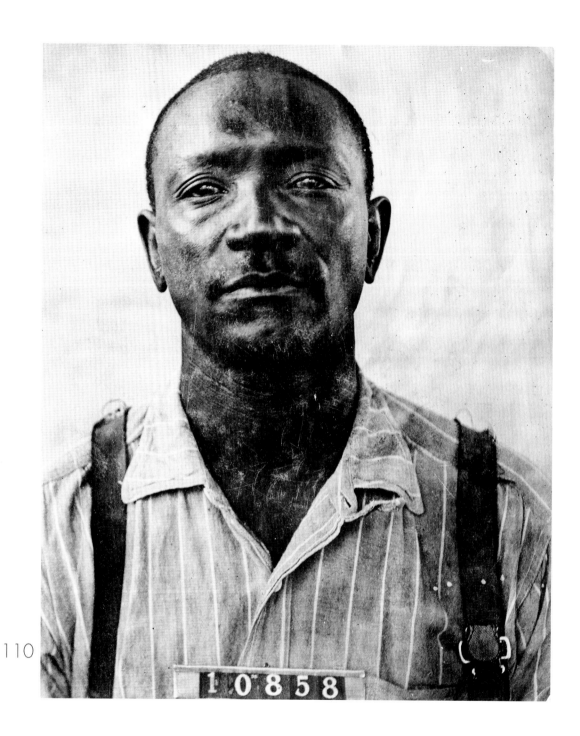

110

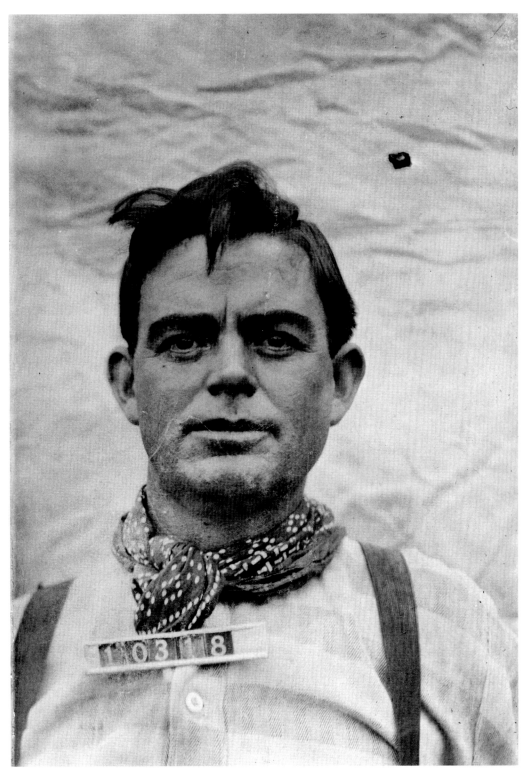

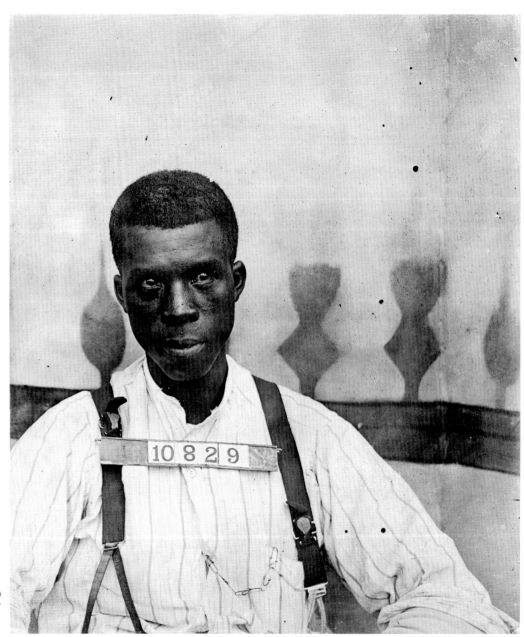

112

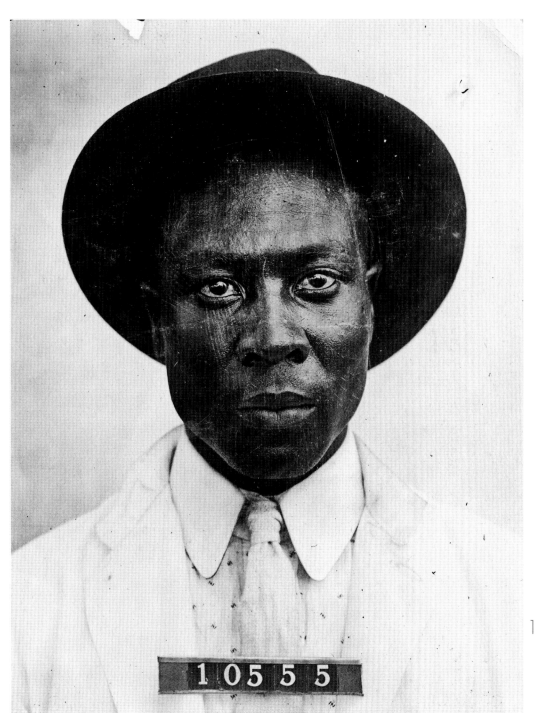

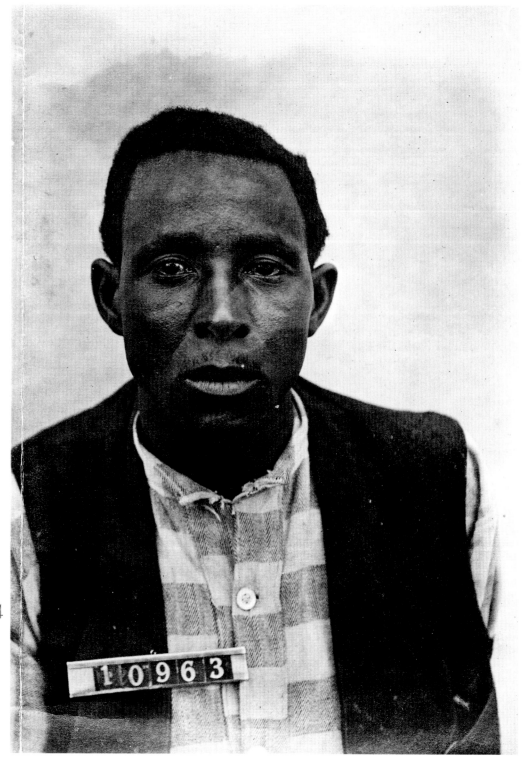

114

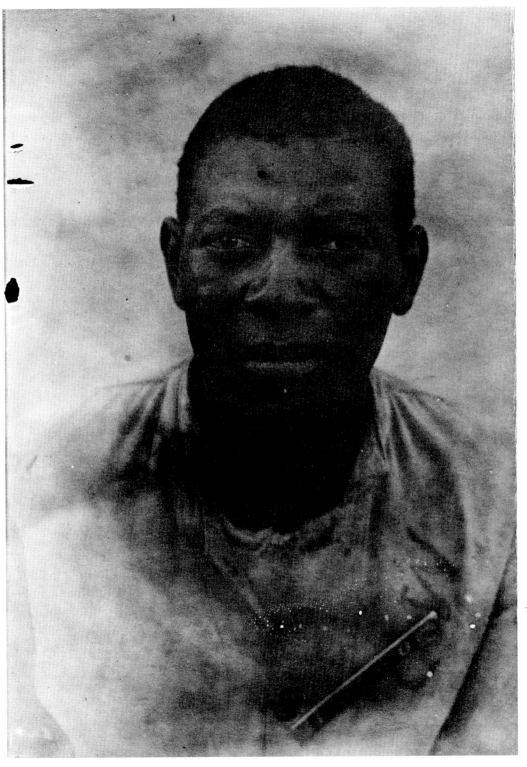

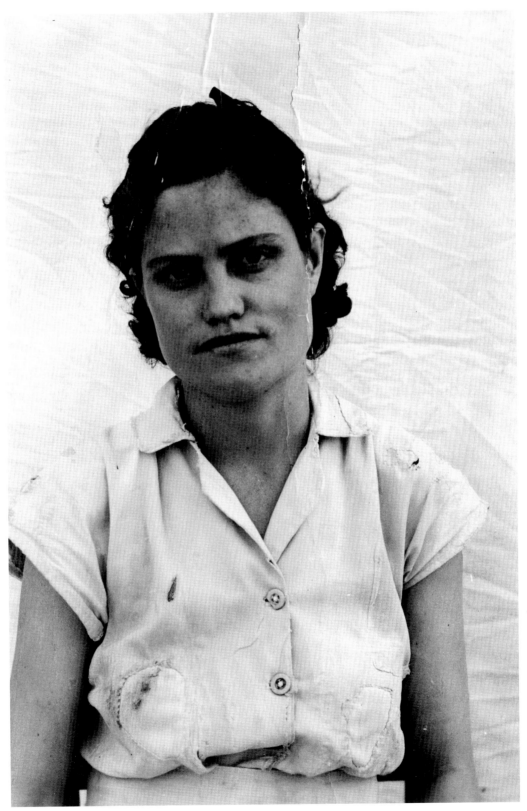

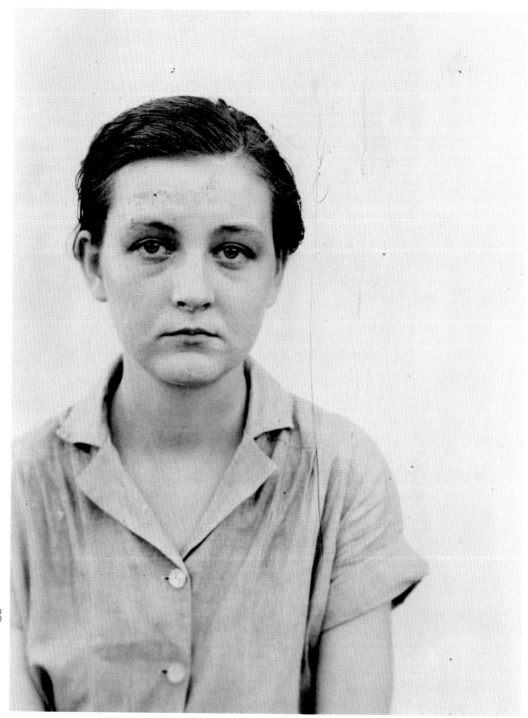

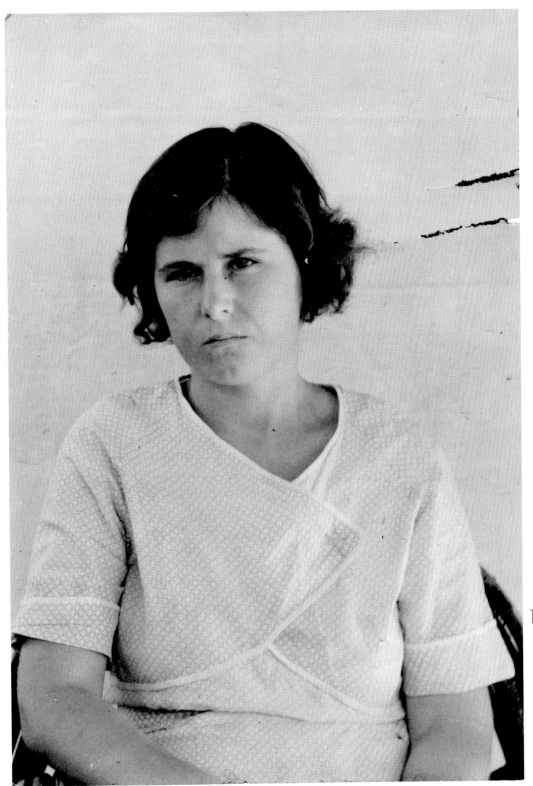

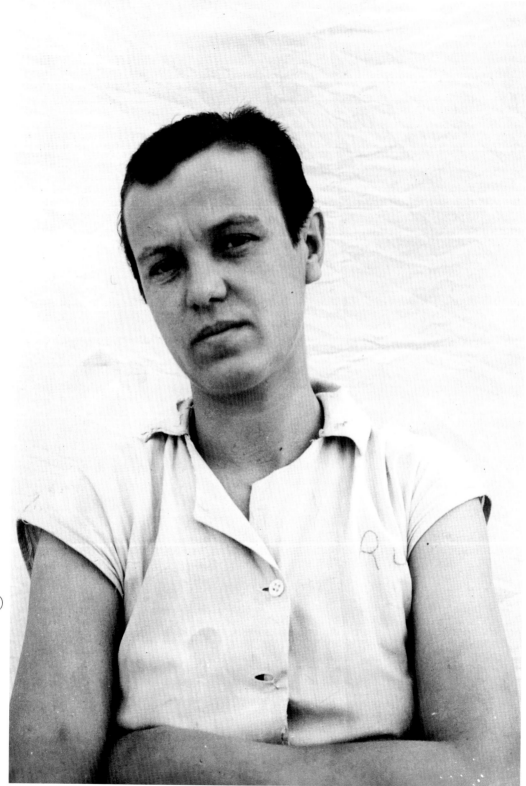

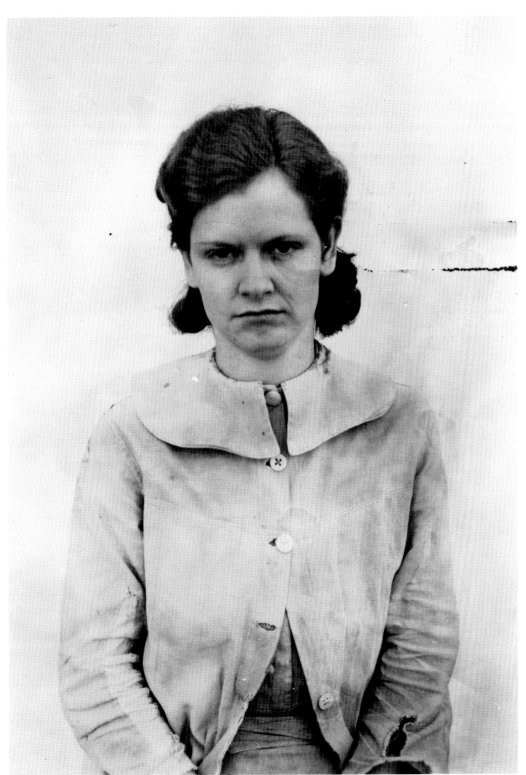

121

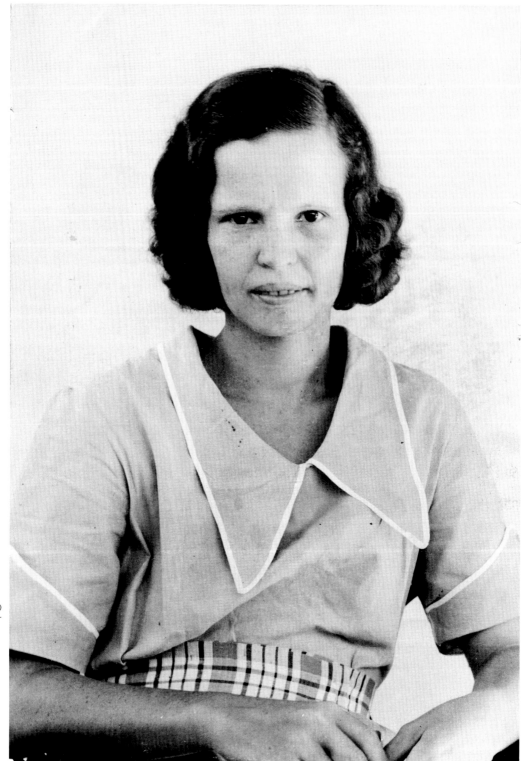

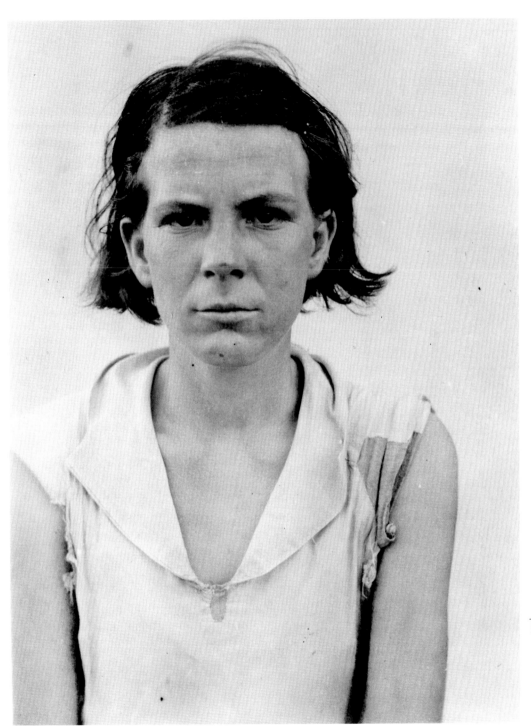

123

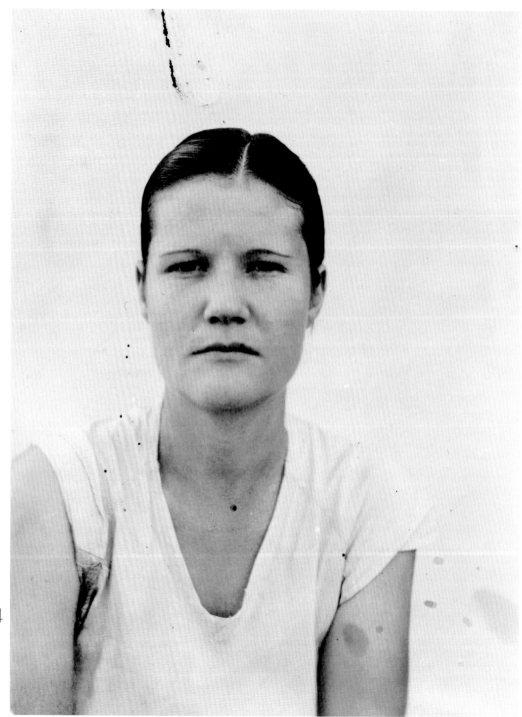

124

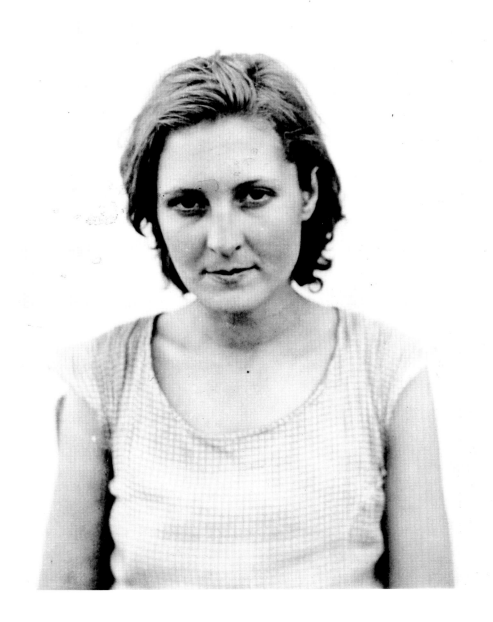

125

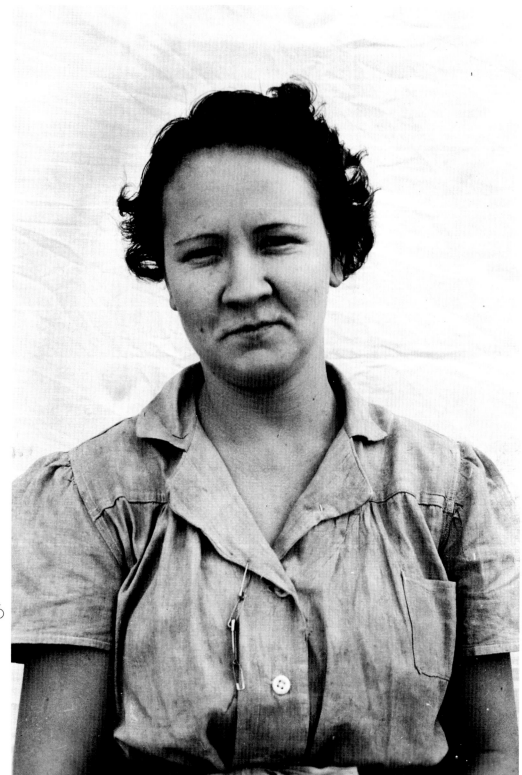

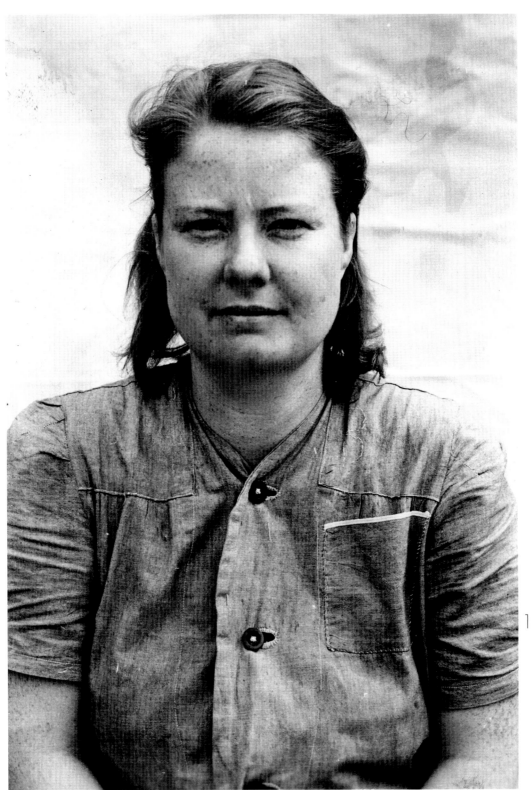

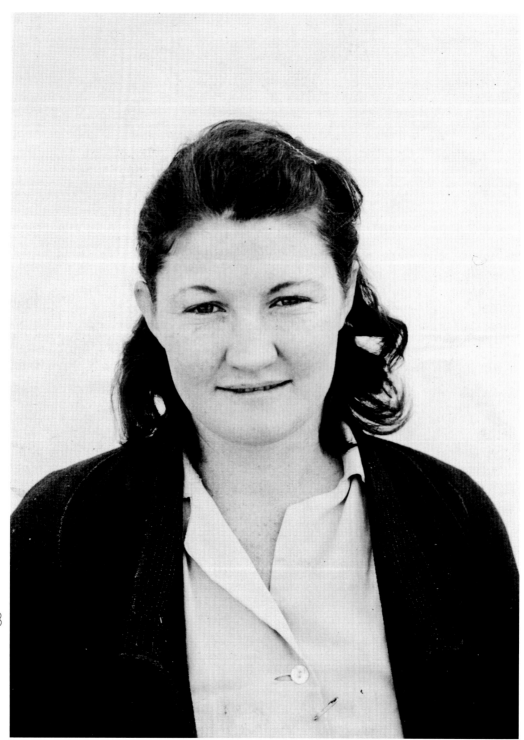

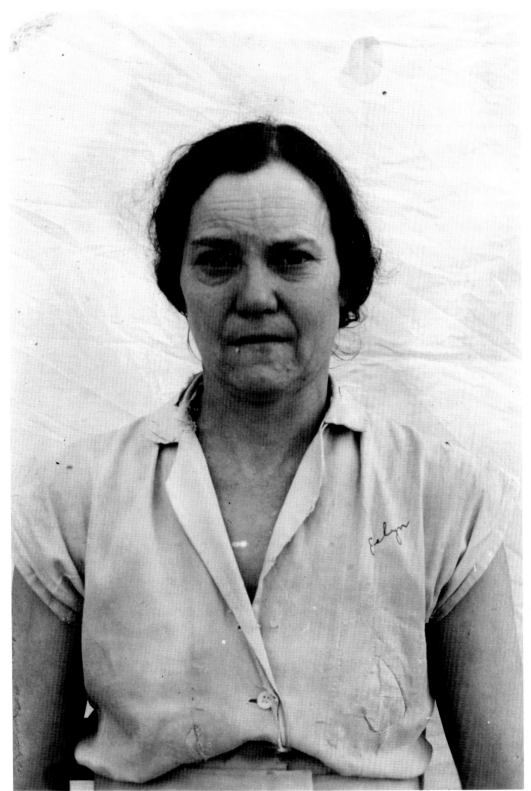

129

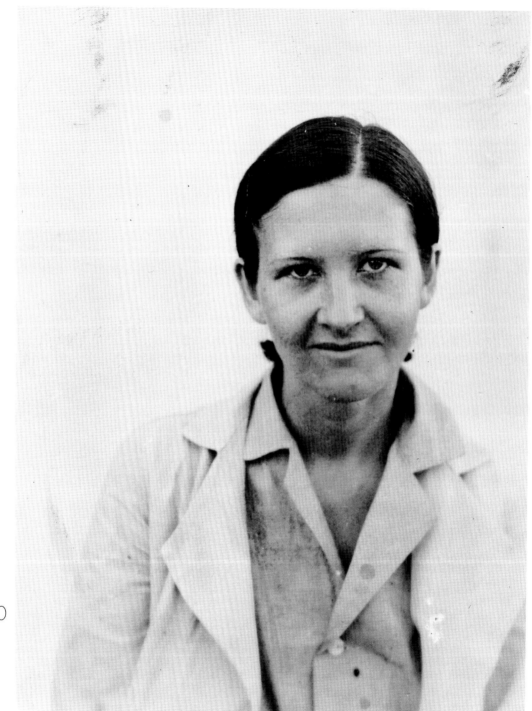

130

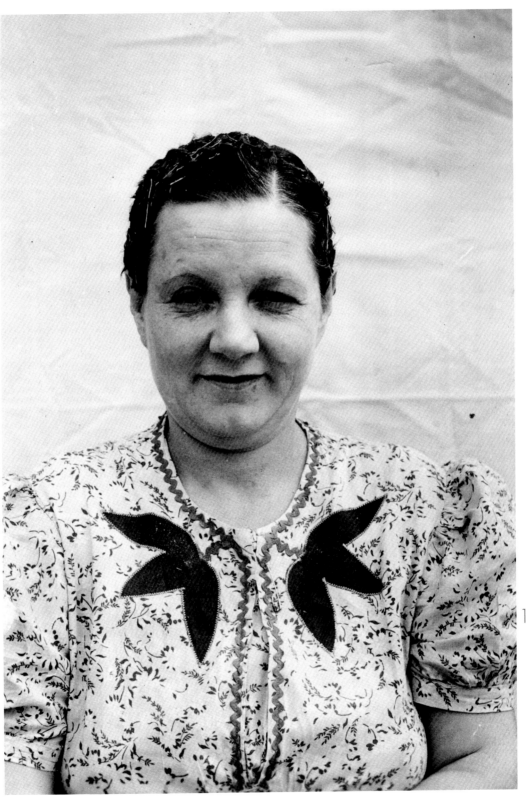

131

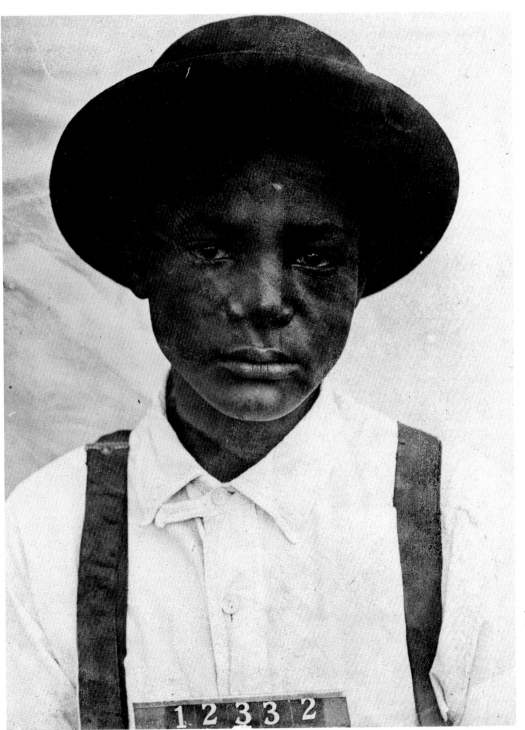

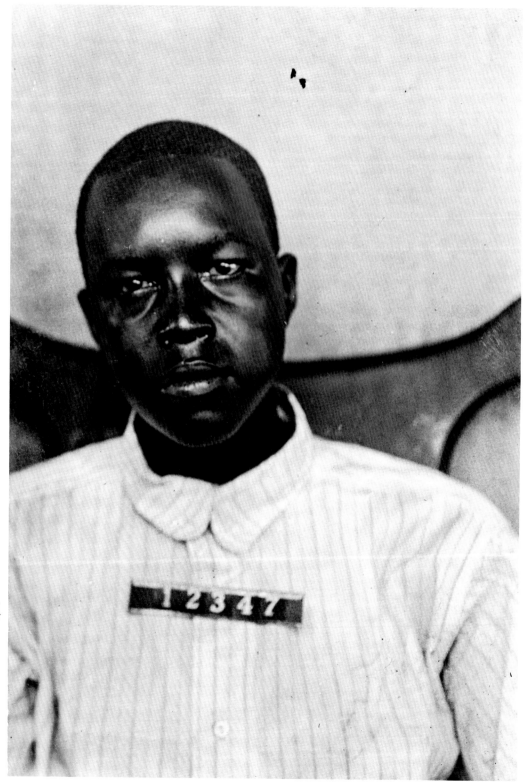

134

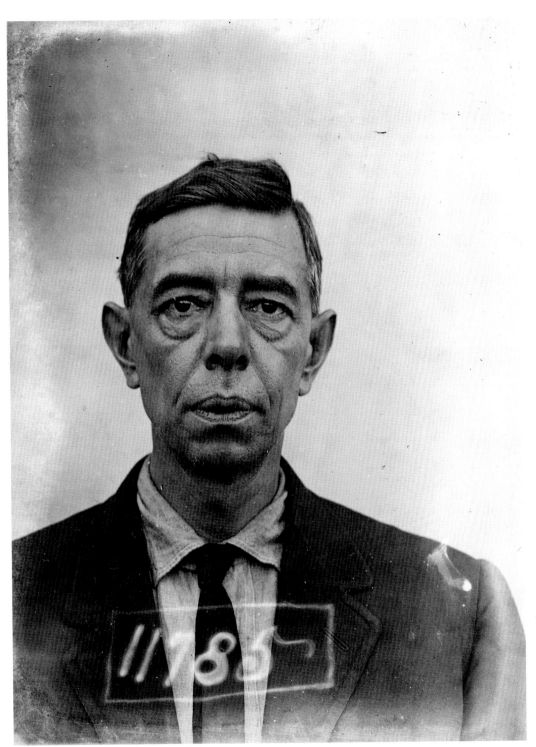

135

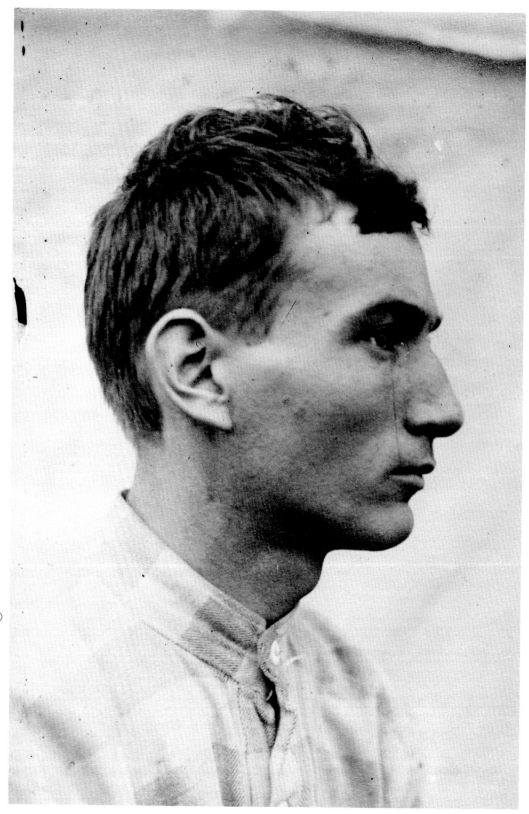

136

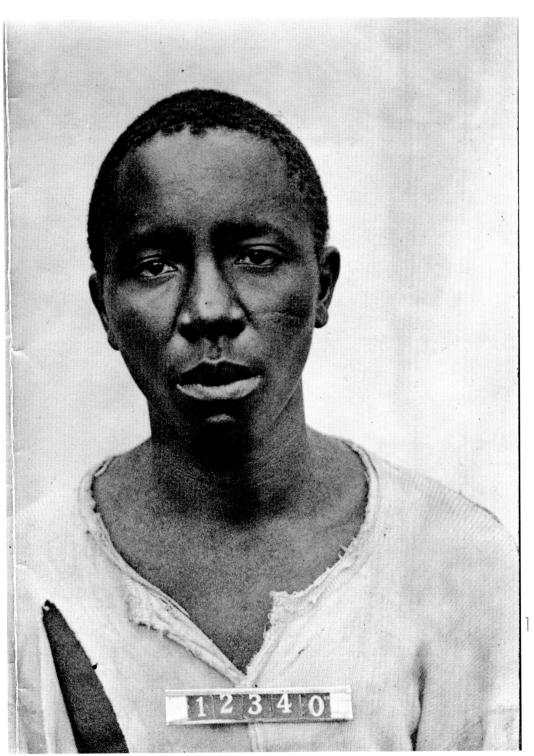

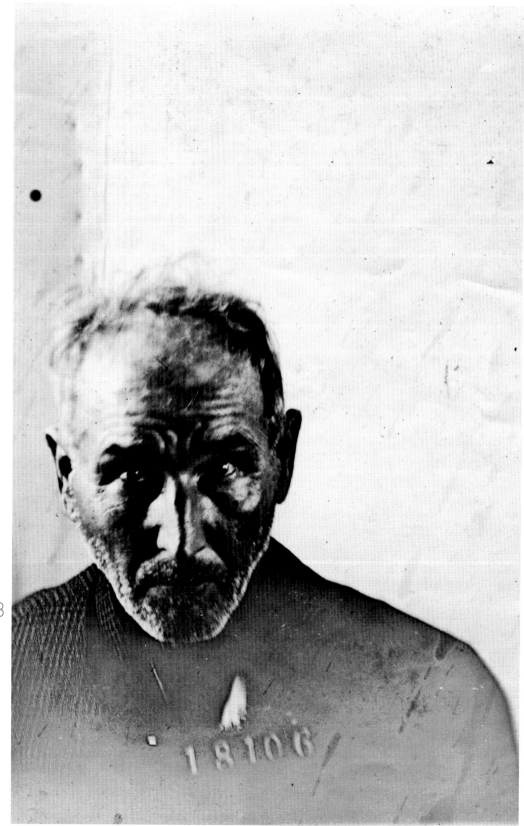

138

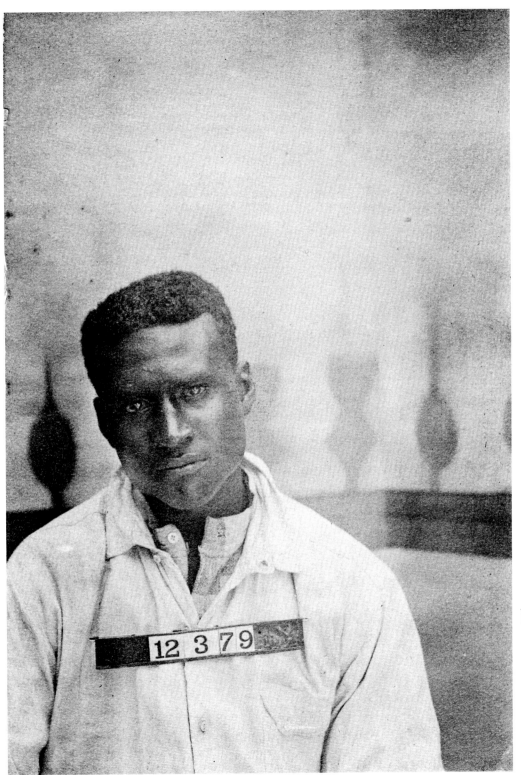

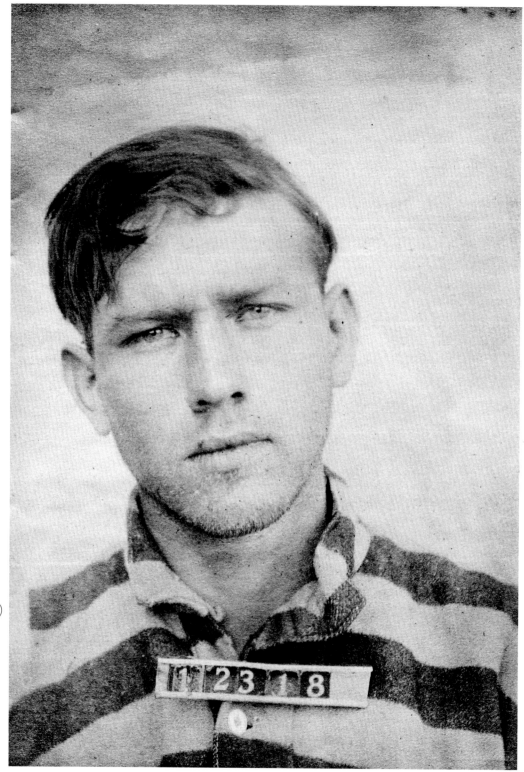

140

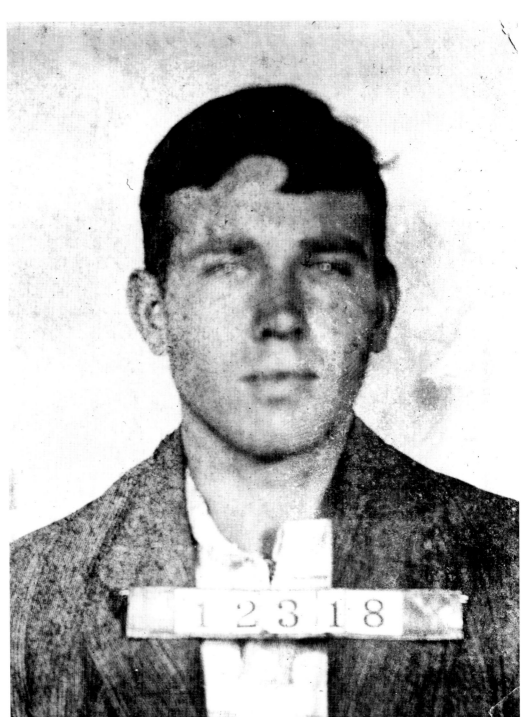

141

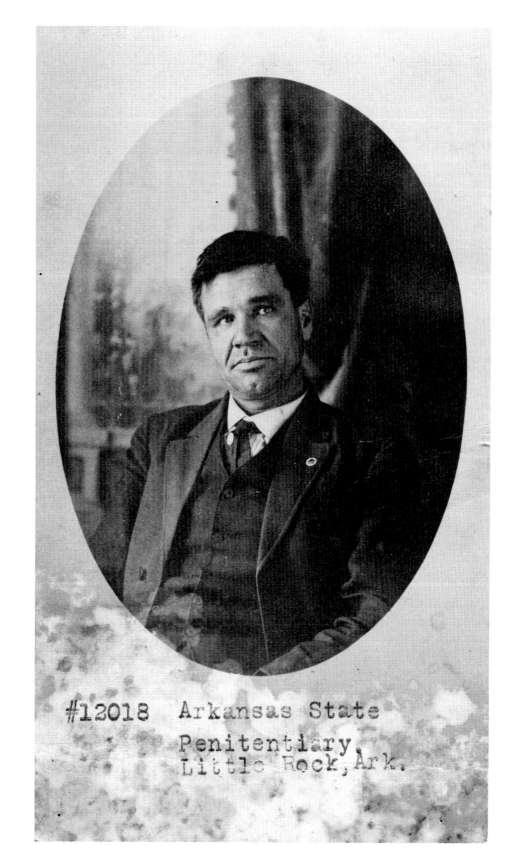

142

#12018 Arkansas State
 Penitentiary,
 Little Rock, Ark.

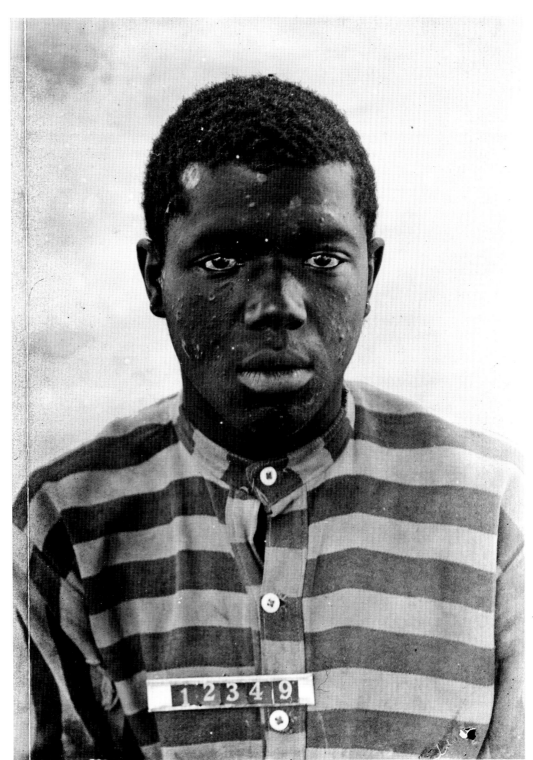

143

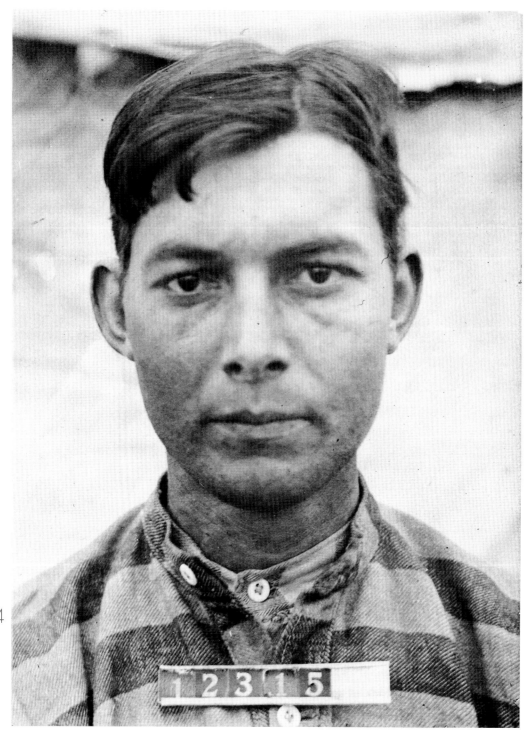

144

145

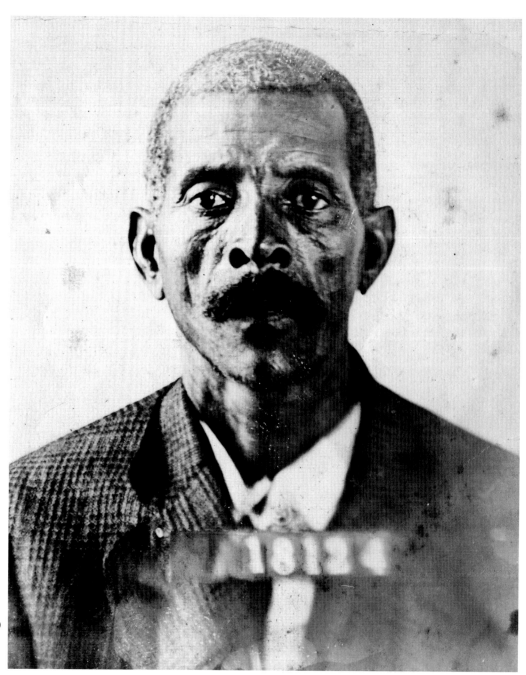

146

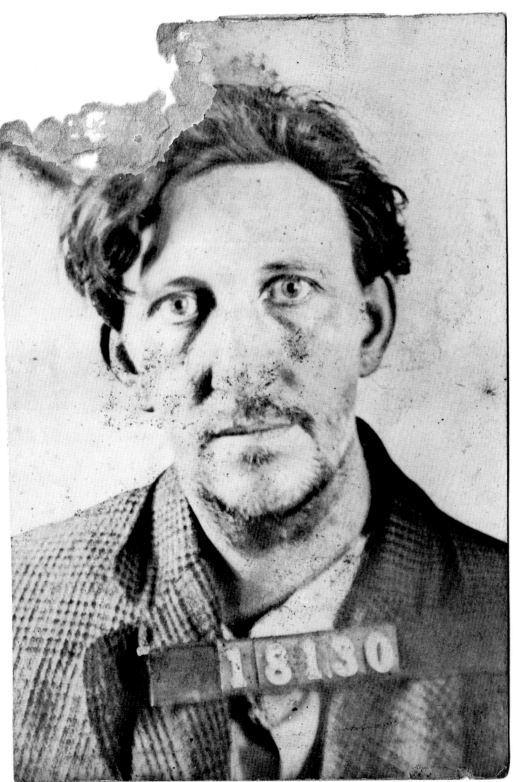

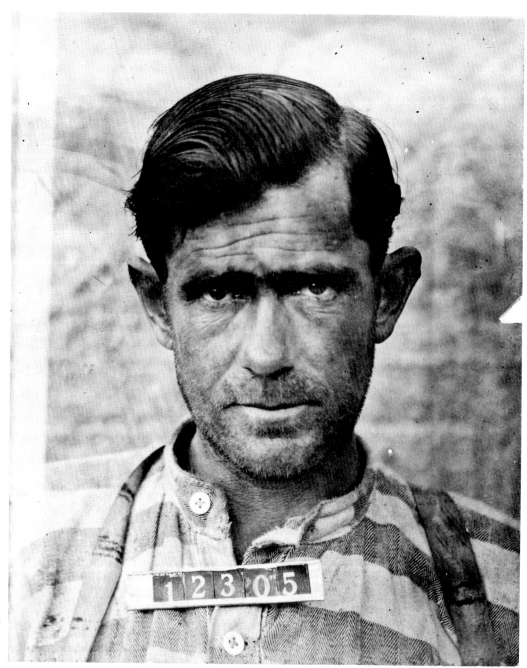

148

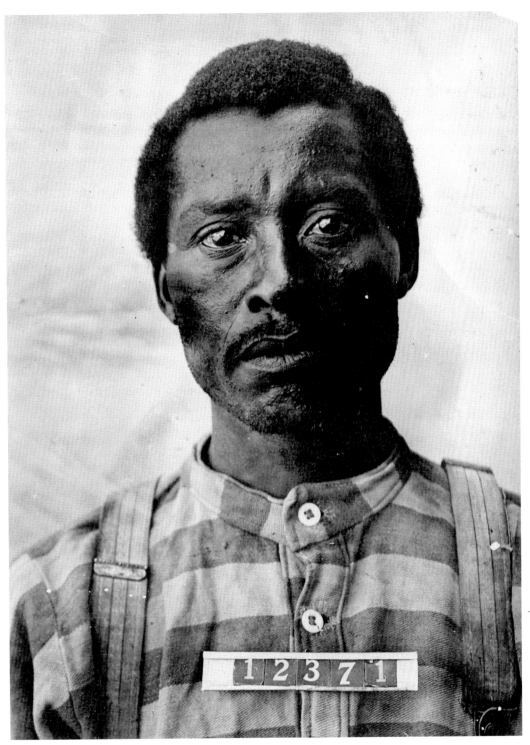

149

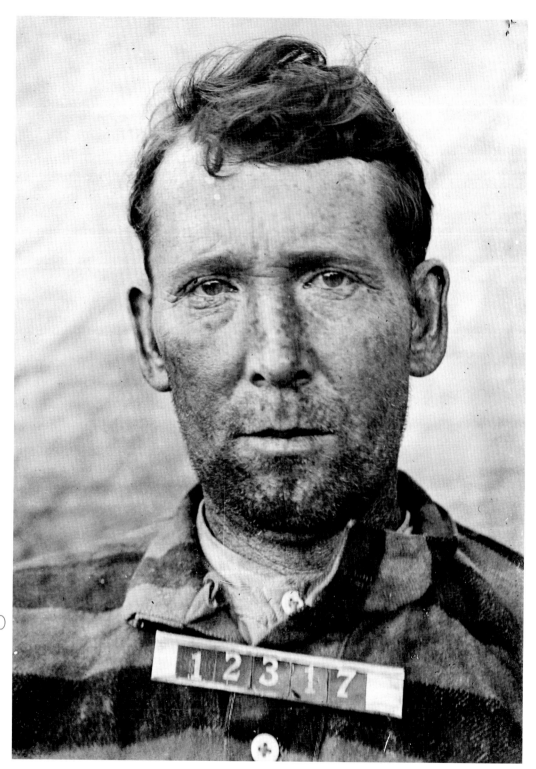

150

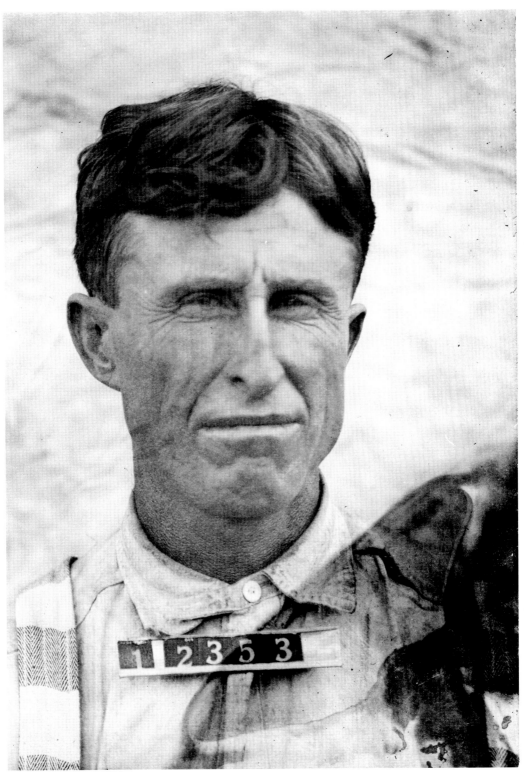

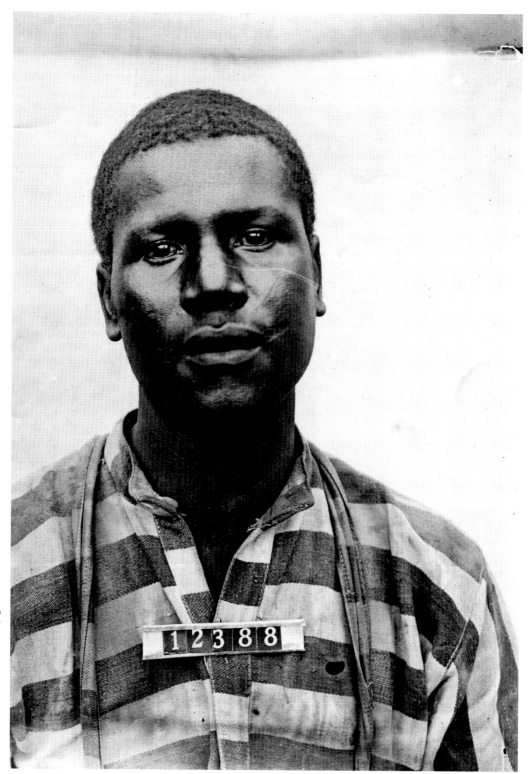

152

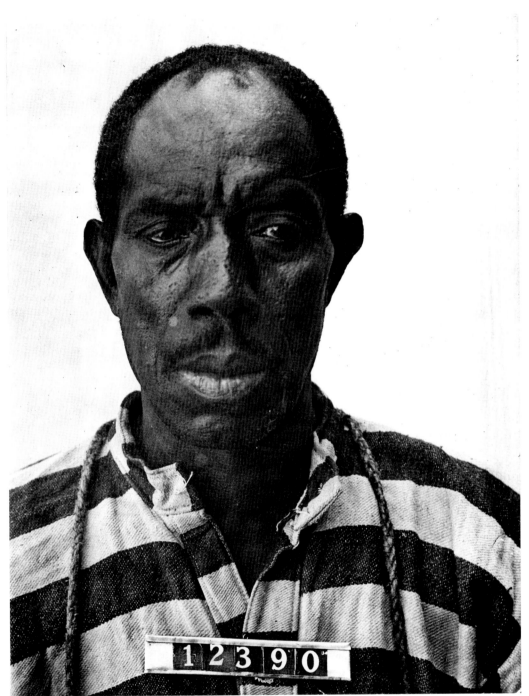

153

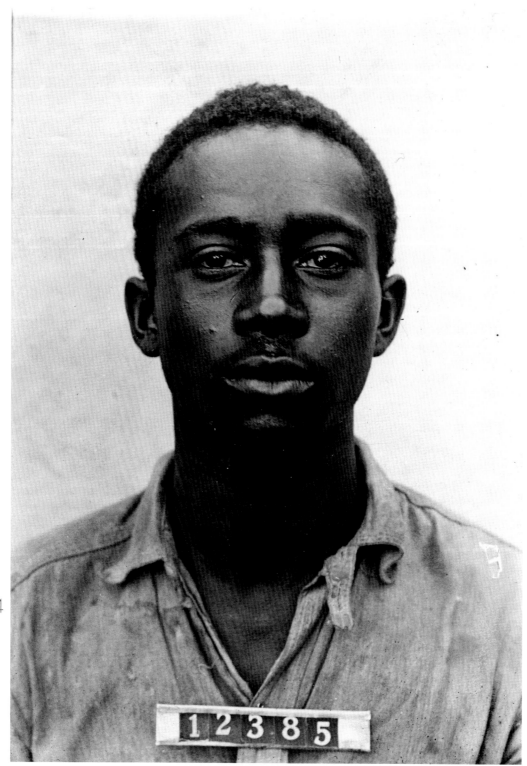

154

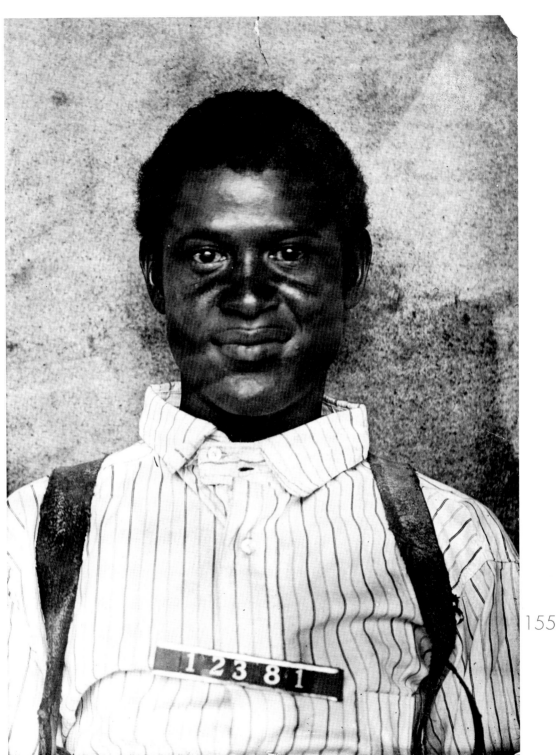

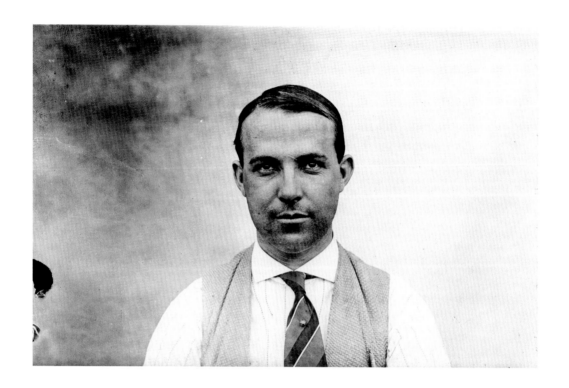

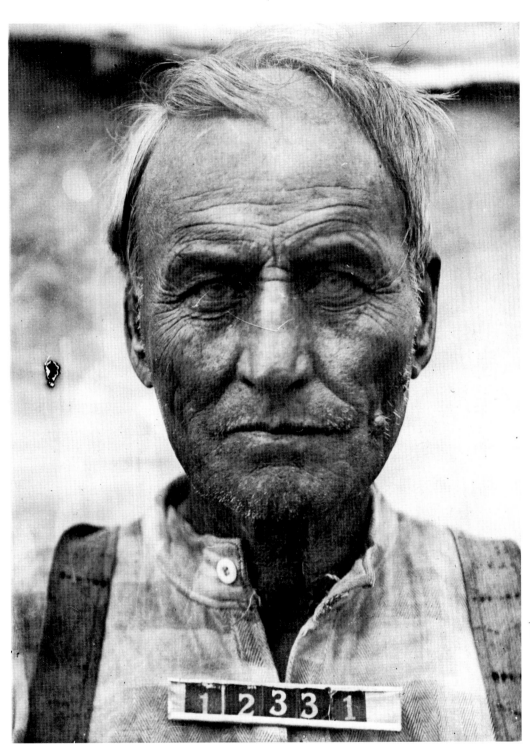

157

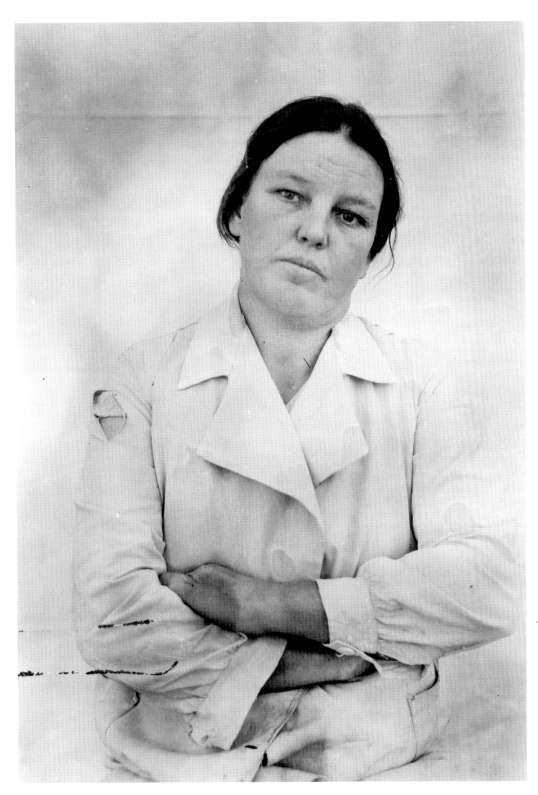

159

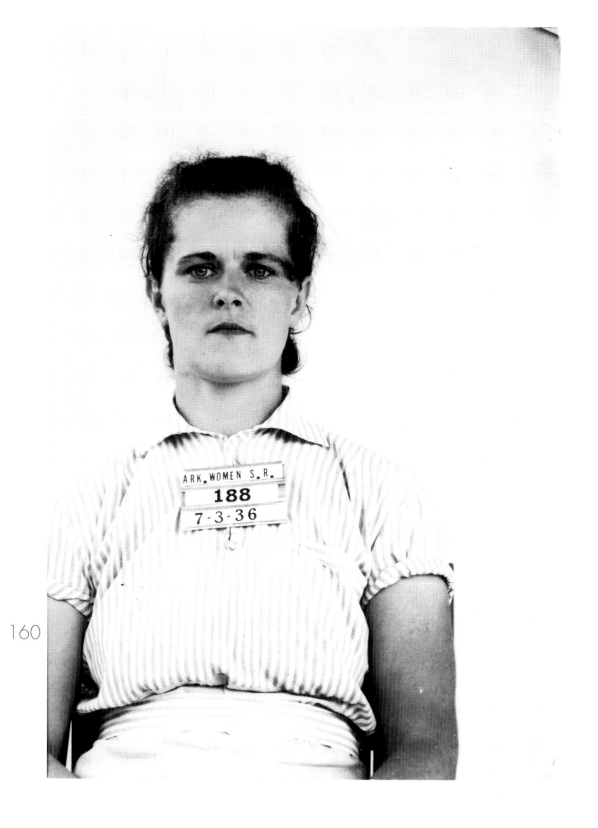

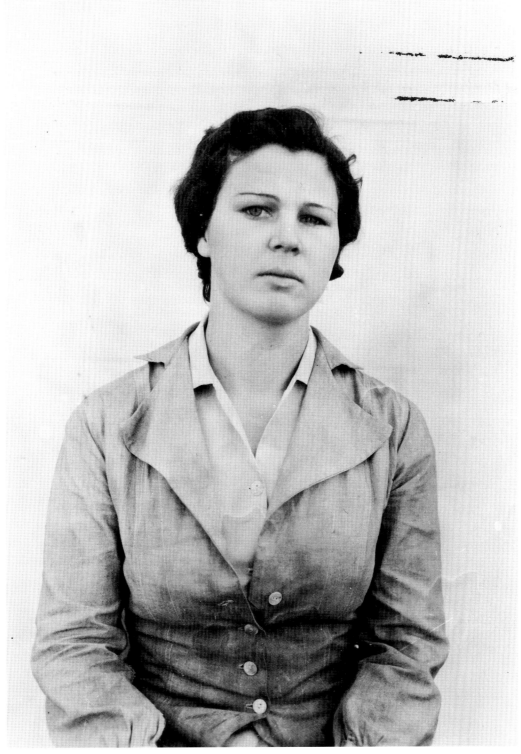

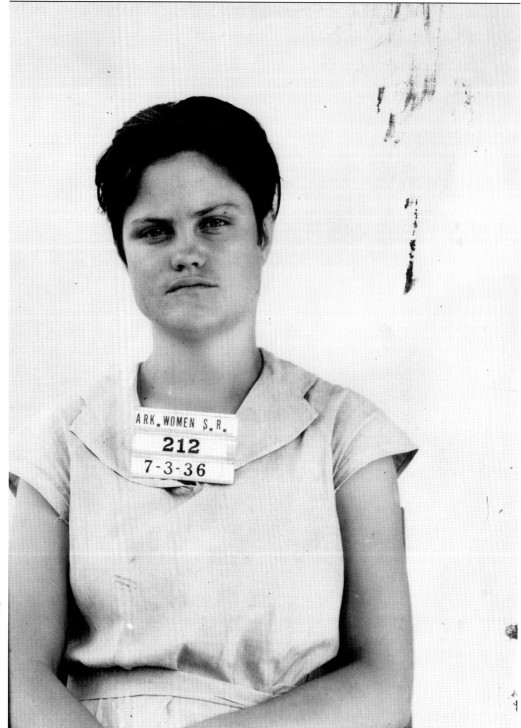

162

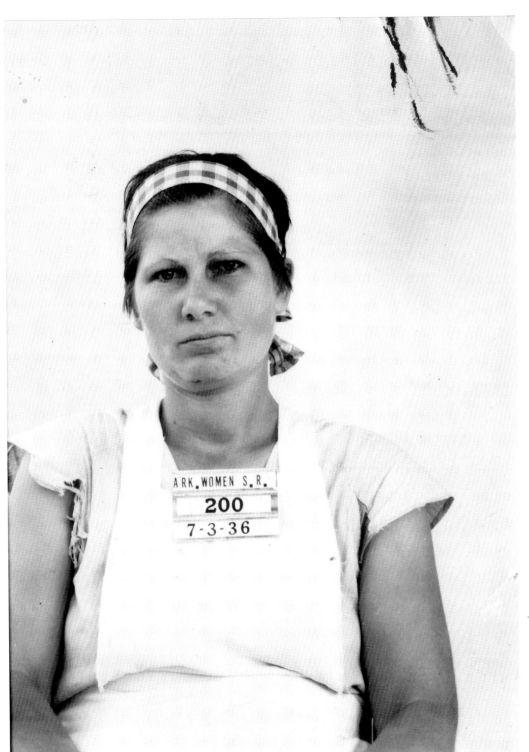

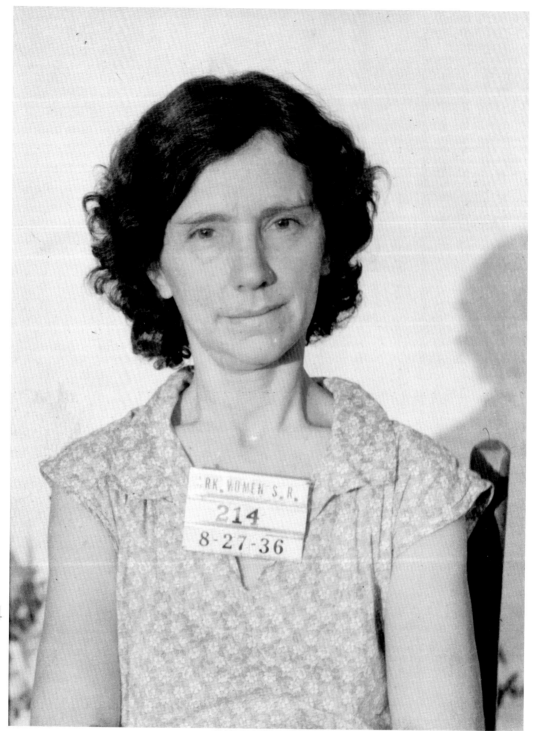

164

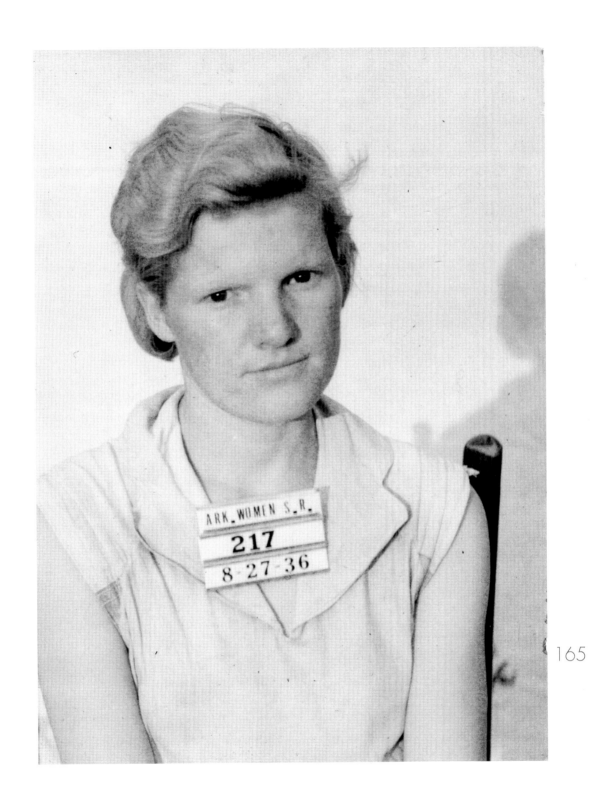

165

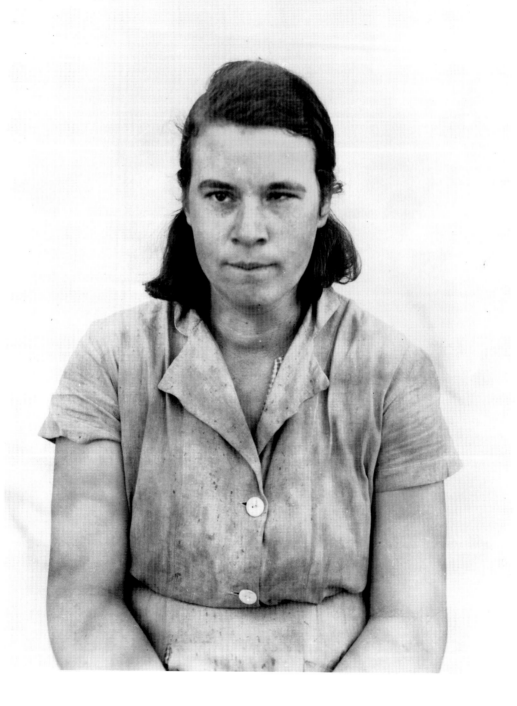

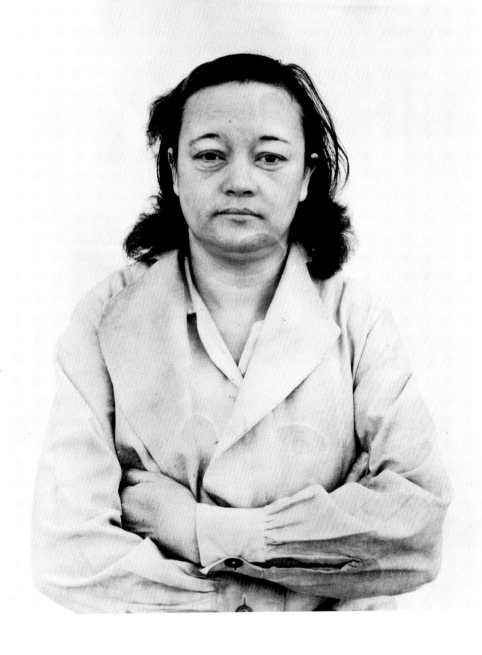

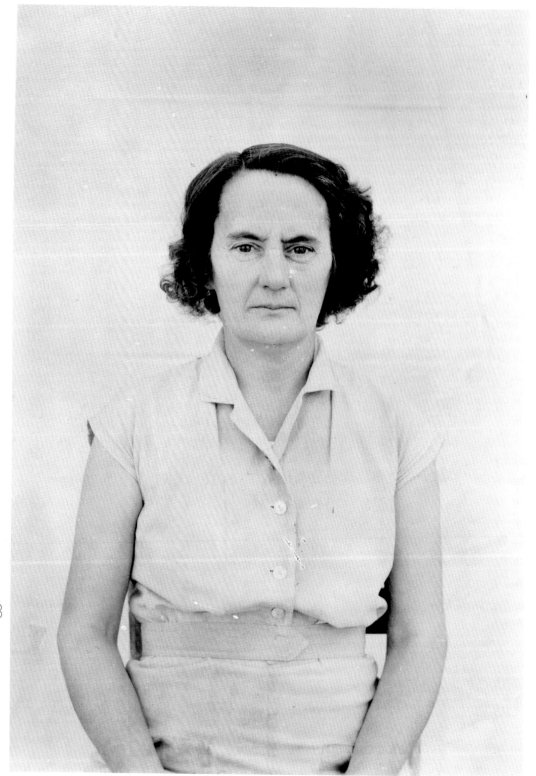

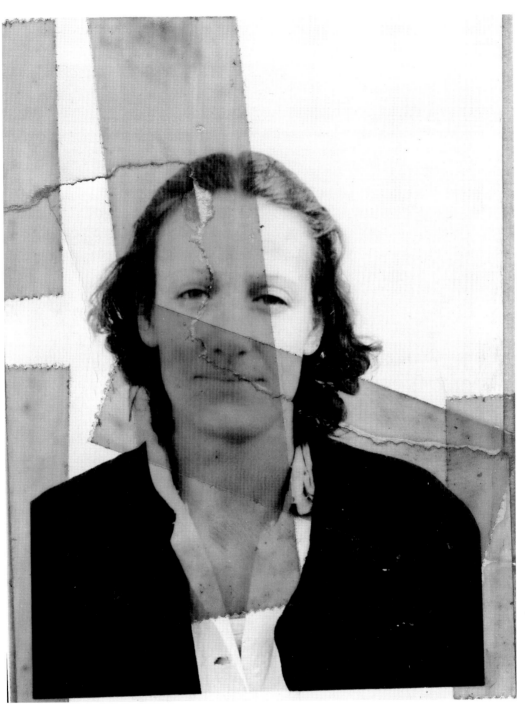

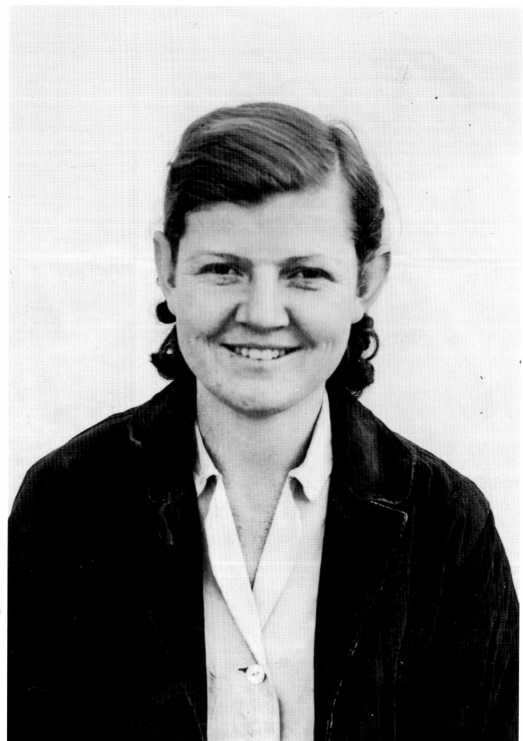

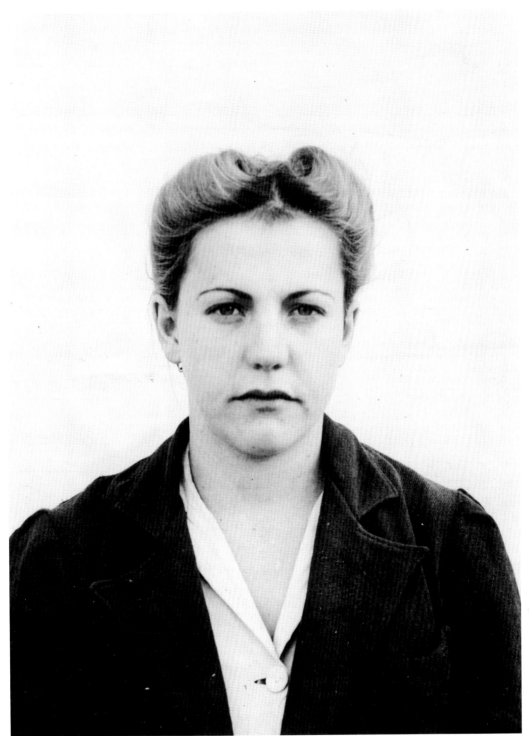

171

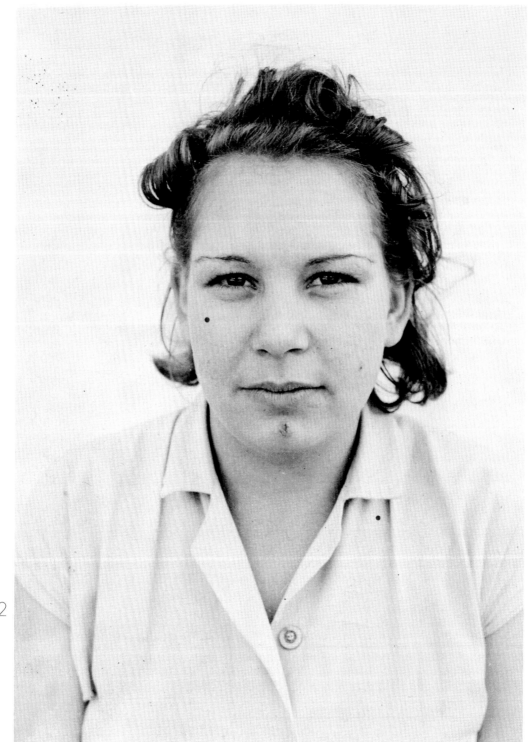

172

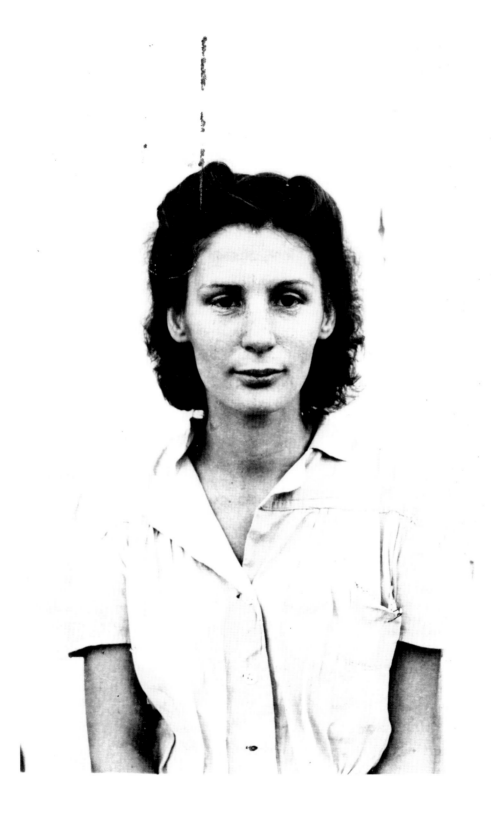

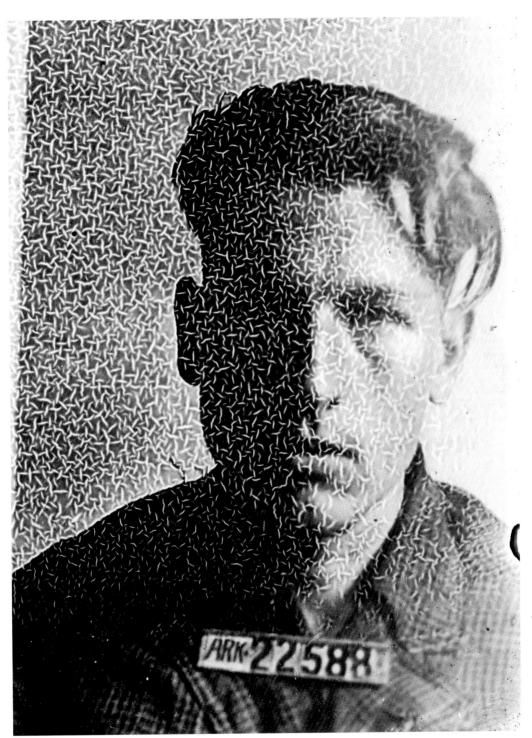

ARK·22588

176

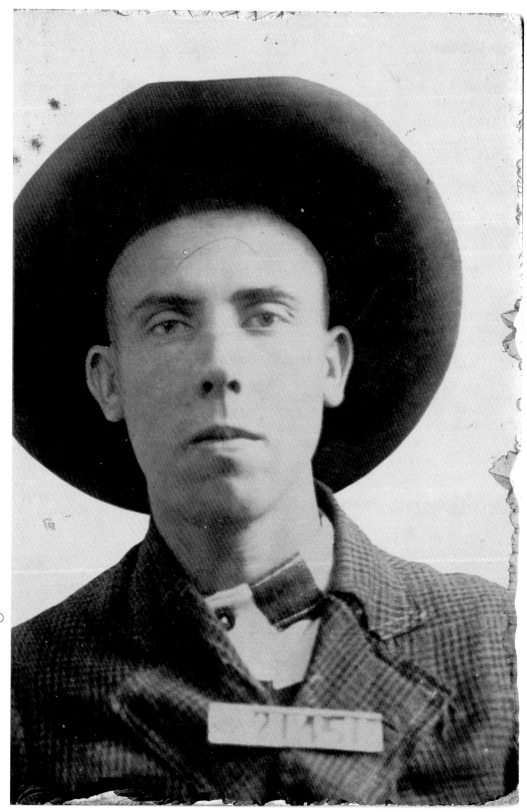

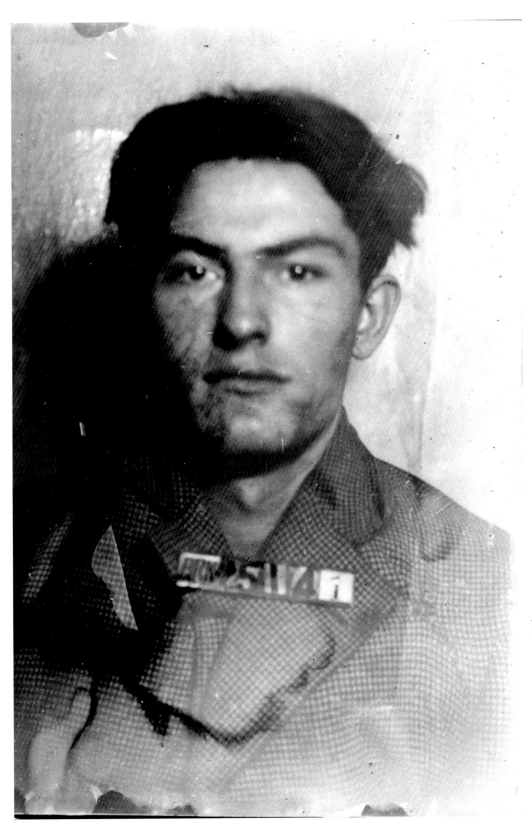

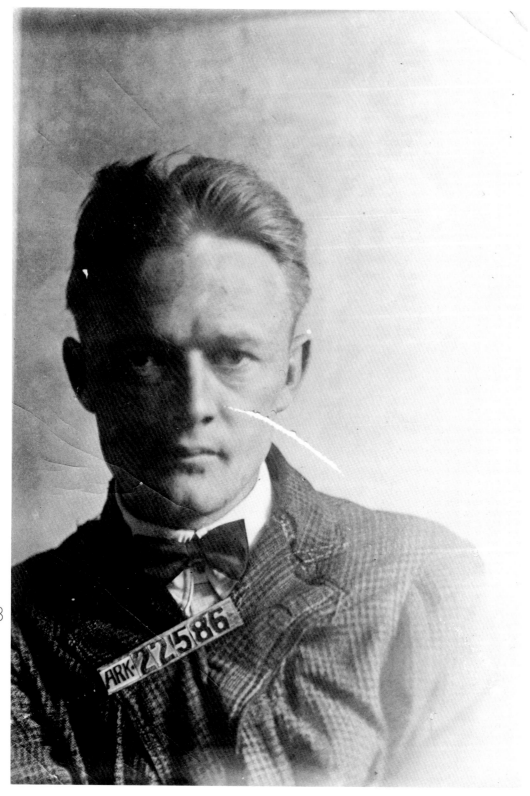

178

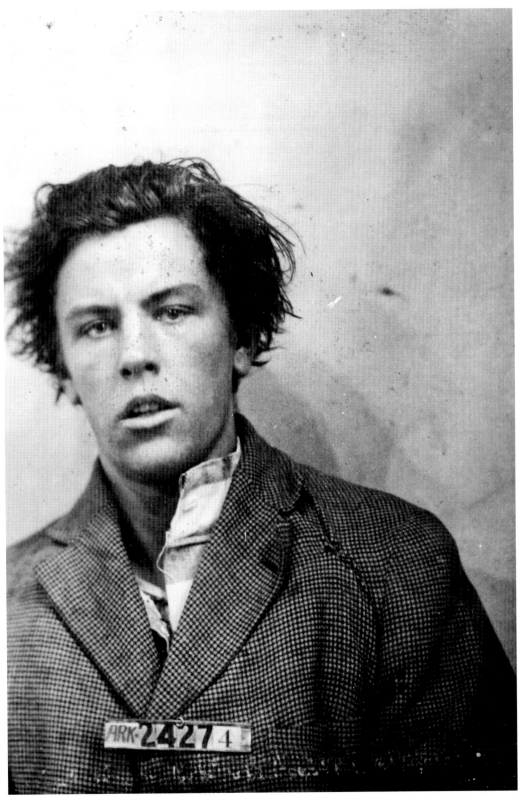

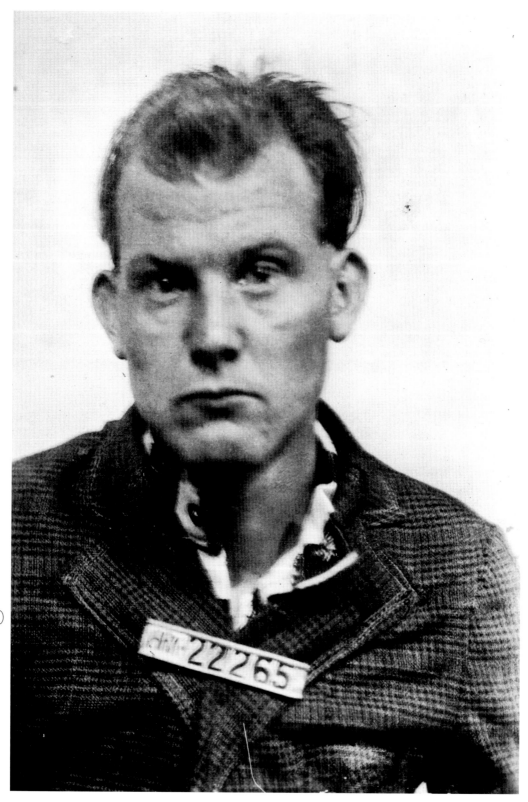

180

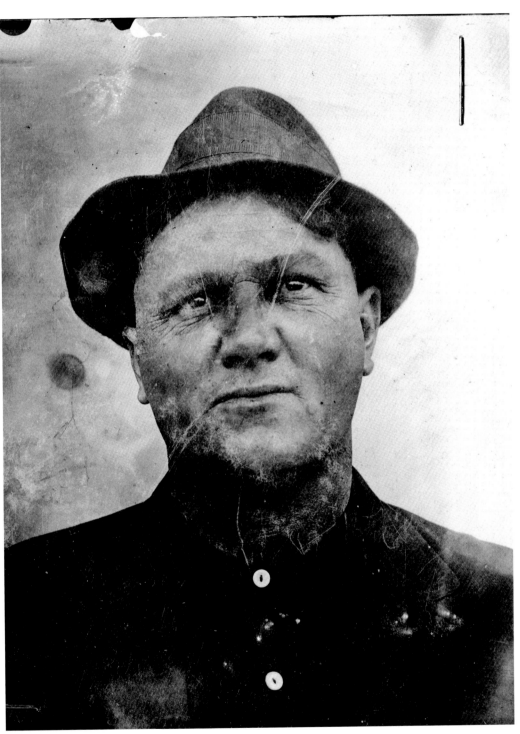

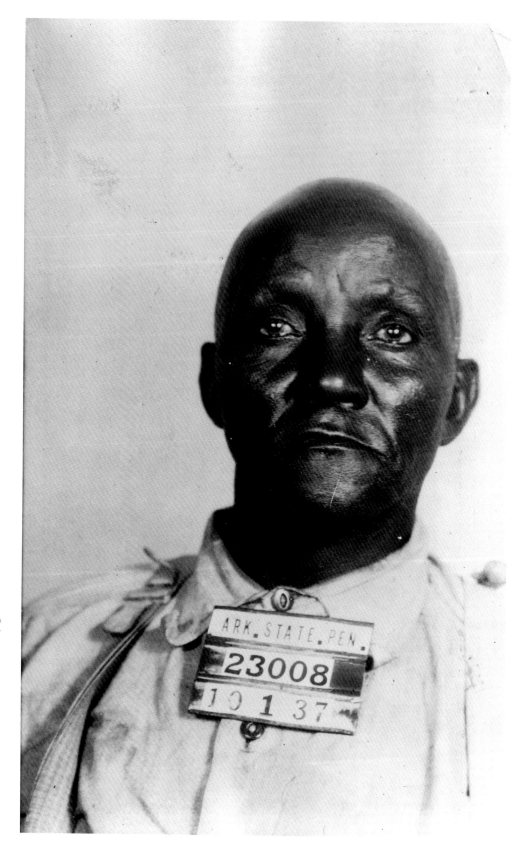

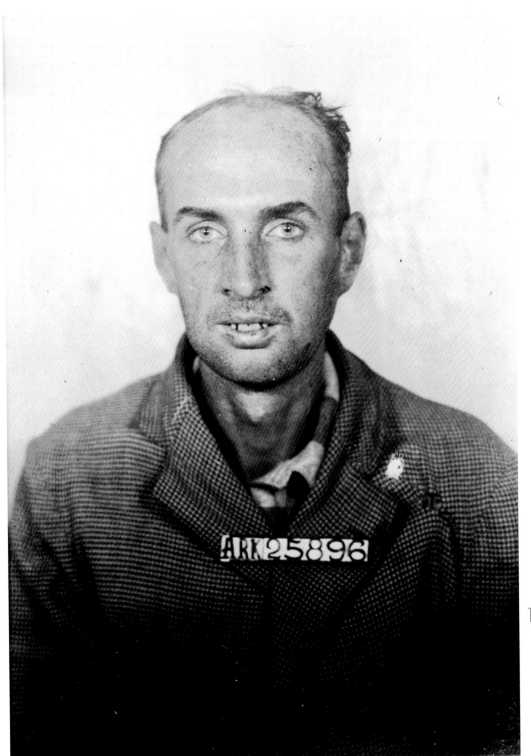

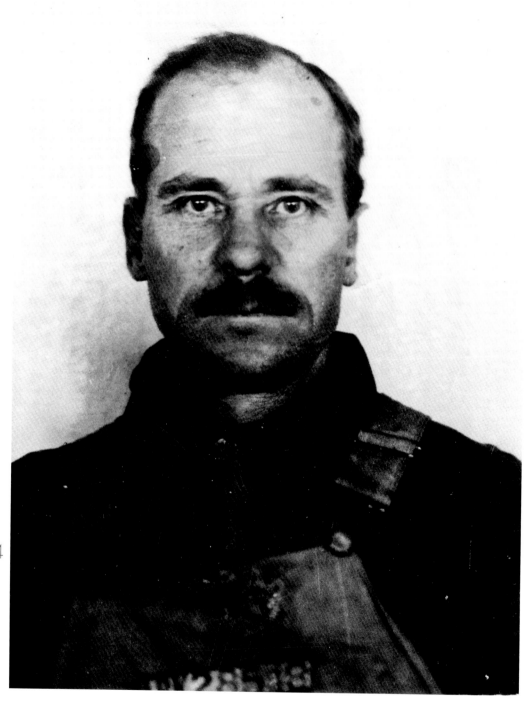

184

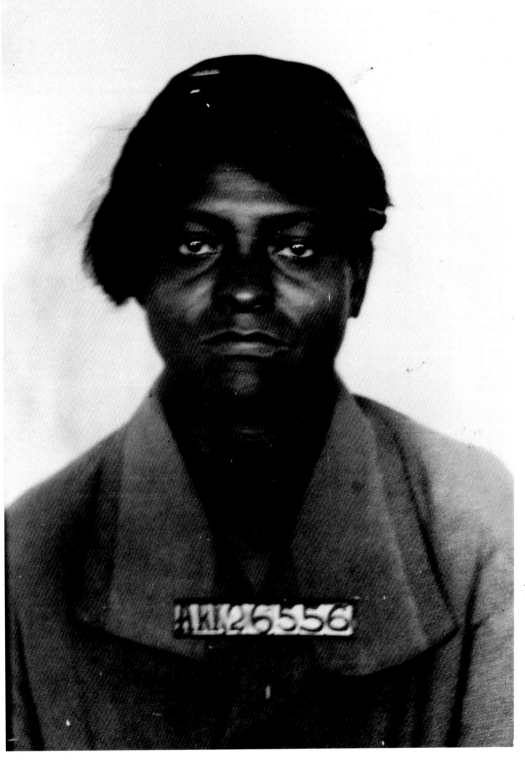

185

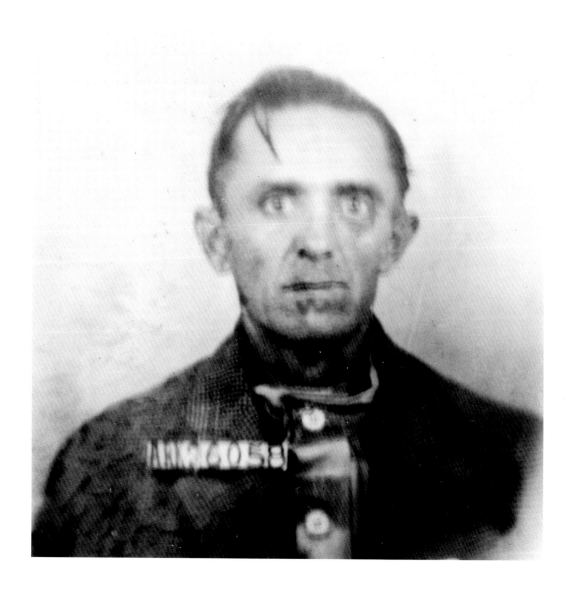

186

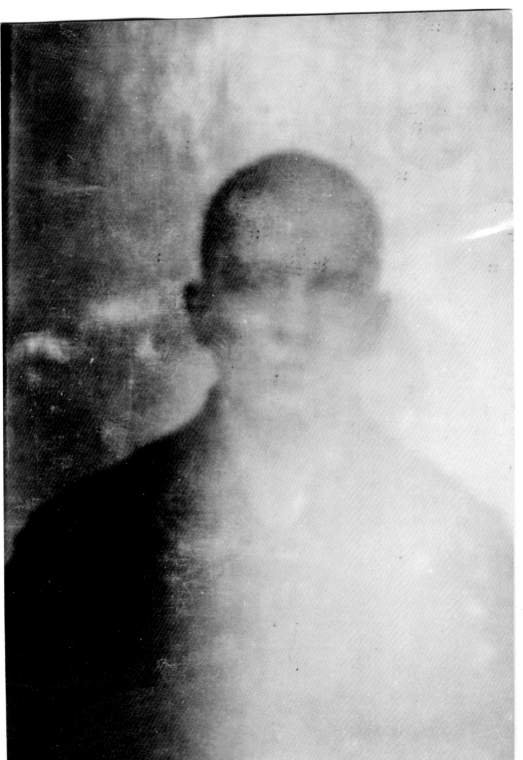

Appendix:
COOTER'S YELLOW PAD

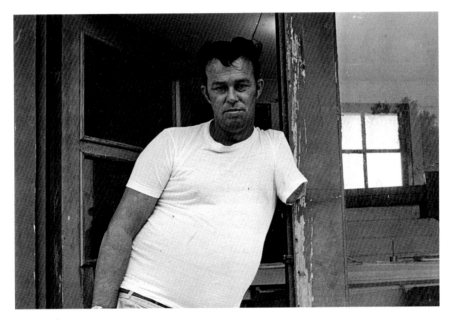

Charles Hackney, whose nickname was "Cooter," entered the Arkansas prison system in 1957, but the harsh conditions he describes—bad food, prisons in which everyone carrying a gun other than the "captains" was a convict, and anyone who didn't work fast enough was whipped—were very close to the conditions endured by the male prisoners whose portraits appear in these pages. The "Tucker telephone" he mentions was the generator part of an old crank telephone. Guards would connect the wires to the genitals of a prisoner they wanted to torture or punish, then they'd turn the handle.

MONDAY OCTOBER 21ST 1957

THE DAY THAT I ENTERED THE ARK. STATE PEN.
NO. 4906 TERM OF THREE YEARS
CRIME—STRONG ARM ROBBERY
FROM LINCOLN COUNTY, STAR CITY, ARKANSAS

The sheriff of Lincoln County and Capt. Lockman—better known as "Pappy" because he was in his middle sixtys but he had retired or quit, I don't know just which—they took me over to Cummins which is in Lincoln County and the sheriff is just a little kin to me. Mr. Tom Walker was the sheriff's name and his brother was the superintendent of the prison until he died in the fifties. But he could still do you some good. Capt. Wayne Henry steped up to Capt. Tom's boots when he died.

So when we got to the prison Mr. Tom ask me if I was ready to face the music. I was so scared I could hardly talk, but I said, "Yes sir." It sure was a sad looking place. Every building was white and you could see guards everywhere you looked and I was doing plenty of that. Mr. Tom and Pappy Lockman took me in the front and turned me over to the convicts that was in charge of the fingerprinting and the mugging. They took my picture and then fingerprinted me and took what little money I had, which was about five or six dollars. I don't know what happened to it, but I do know that I didn't get it back. I had a carton of cigarettes which they let me keep.

When the front office was through with me a trusty told me to follow him. So here we go down a narrow hallway. We went about a hundred feet then we came to a bigger hall. This was the hall between the barracks. There was 1-2-3-4 barracks. There was a few trusties out in the hall and there was a big desk on the left side of the hall. We stopped there. There was a trusty sitting at this desk. His clothes was starched and ironed and his boots looked like they had a spit shine on them. He took my name and said, "Put him in 4 barracks and put him on punk row." When we got down at the barracks doors I had to take off all of my clothes. Then the door was unlocked and I stepped in and I got my shorts and undershirt, socks, belt and a pair of air force flight boots back and the carton of cigarettes, then the convict who was leading me around took out his pocket knife and cut the notch out of my boot heel. [Southern convicts traditionally wore shoes with notched heels so trackers could tell which footprints belonged to an escaped convict and which belonged to everyone else.] It must have been about 10:30 by that time.

After I got a bunk and the barber got through with me we went to dinner. It is a good thing that I wasn't very hungry because all we had was soybeans and cow peas

and some greens of some kind. I ate a few of these things which had no seasoning at all. There was just water to drink. We went to the barracks and I took a nap. At 3:30 we went to supper. The chow was the same as the dinner was, except when we came out of the messhall I had to take my boots off and my socks off, then I had to take everything out of my pockets and then be shook down by a trusty. When he got done with me I went down to the barracks. The convict that was in charge of the barracks told me to catch my bunk because the longline would be in in about an hour or so. It was just about 6 o'clock when they started coming in.

Each man counted when he came in the barracks door. If there was 10 men in the barracks the first man said 11-12-13 and so on up until every man was in the barracks that lived there and then the door was locked. There was a gun room about 25 foot below the door in the end of the hall. When the count was all cleared and they was sure nobody had ran off, then the guards all came in and put their shotguns and rifles into the gun room.

Then in about thirty minutes I heard someone up in front of 1 barracks hollering for dear life and it sounded like a shotgun was being fired. I heard one of the men behind me say, "Poor bastard, that's Big Abe slanging the hide." Big Abe was the longline captain and he was a big brute of a man over six feet tall and well over three hundred pounds. That man had no feelings at all for a convict. Then he got through up in 1 barracks and came down to 4 barracks and got three out on the hall floor and began to whip one of them. They had to lay down on their stomach and the hide was supposed to hit you on the buttocks, but Big Abe was catching him from the top of his head to the bottom of his feet. There was more begging out there in that hall than in any church I have ever heard. These men were bleeding when they took a bath.

The reason that they got the beating was because they didn't pick enough cotton for the day. That was not all that got the hide.

I heard then the other convicts talking about three that had to be took to the hospital. One of them had been shot by one of the convict guards. They didn't say if he lived or died.

A few days later there was me and seventeen others transferred to Tucker. That is a smaller prison up in Jefferson county about 40 miles from Cummins. And a tough S.O.B. I found out in just a matter of hours. When we got over at Tucker it was dinnertime. They run us in the mess-hall if it could be called that. We set down to some more cow peas and turnip greens which was just about half done. But one of the cons said, "There is meat in the peas," so I got the bowl and found the meat all right. It was worms, but there was plenty of them and we ate them.

There was this little fellow that came over with us. He was a real small kid. But he was 27 years old and about 4 foot 11 inches tall and weighed about 96 pounds. He was as tough as a boot. He said he had just got out of Jefferson City, the Missouri state prison. That little fellow said he hadn't had a smoke in two days, so I gave him one. He thanked me and said, "I will wash your laundry for you if you will get me a pack of tobacco." I told him I would tonight. I had sold my flight boots over at Cummins before I left. I got three dollars for them and I was getting broke.

That evening Capt. Bobby Brinkley loaded us up and took us to the Warren field where the longline was picking cotton. When we stopped we jumped out like a bunch of hogs. There was guns everywhere I looked. The guards was very young, maybe 23 or 24 years old. You could see their ribs. They was underweight. I knew if the guards was in this shape they sure wasn't feeling worth a .

Capt. Brinkley ask me if I could pick him any cotton.

I told him I could. He said it is a damn good thing I could. I was just about the biggest in the transfer. I was six-one, I weighed 160 pounds at that time, but I lost down to 136 in 2 months. That evening the short hairs—that is what they called all of us—just helped the others on their rows. I weighed up 65 pounds that evening, but I caught the hide the next day. That was the worst ordeal I have ever had in my life. I got 12 licks from Capt. Brinkley because I couldn't keep up. I wasn't the only one out on the turn row, just about all of the short hairs was out there. We was going our best. But Capt. Brinkley said that was not good enough. There was grown men crying and cursing. They had just about give up.

Then Captain Floyd Billings drove down to see how things was going. Captain Brinkley left and it was better after that because the riders took one of the girl-boys over in the cotton trailer for a little romping.

In the next week the cotton was all picked. We had some corn to pull at the county line which was five miles from the building. We got to the corn field early that morning. It had rained that night. There was water in the middle and we had to tie a knot in the sacks to keep from getting the corn wet.

I filled my sack and gave it to the man up in the trailer. He poured out the corn and layed it on top of the side boards and it fell off next to the guard line. When I went to get it the shotgun guard fired at me and one of the .00 buckshot caught me in the arch of my left foot.

I fell to my knees. This pillhead helped me up and out in the field. By that time it was getting some feeling back in it. My foot was so big in about an hour it looked twice its size. Capt. Brinkley started to whip me for getting shot. He told the rider to build him a damn fire so he could cut that shot out of my foot. When the fire was

burning he got out his knife and stuck it in the fire. The truck driver told him if he cut my foot he was going to have a lot more cutting to do when he was finished with me. Capt. Brinkley changed his mind and made me walk to his truck which was about 300 yds. away and put the guard in the cab with him and me in the back. When we got to the hospital I had to walk in and the convict doctor asked what had happened. Capt. Brinkley said that "The sorry S.O.B. got over the guard line." Which was not true. But there was not much I could say or do. Brinkley did get to cut my foot open. I believe that was the worst sound and feeling I have ever seen or heard. They didn't even have anything to kill the pain. I finally got loose and Capt. Brinkley said, "I hope that it rots off."

I stayed in the hospital for about a month. When I had been there a month or so I got a visit from my mother and father. But there was a guard with me and I couldn't tell them what was wrong. That pellet stayed in my foot. When I got able to go back to work, Capt. Brinkley carried us over in the Judy hole. He said we was going to scrape up some cotton. We was supposed to have been through picking. It was on a Saturday. It was in January and cold as hell.

Capt. Floyd had gave orders to let the longline catch all the rabbits that we could since all the work was just about done.

I was picking in a row next to a Indian boy. He was maybe 26. He was a good convict. His name was Frank Neal. Frank was from Oklahoma. One of the riders, J.L. Montgomery [a convict guard], was on a horse after a rabbit. I saw J.L. coming and I told Frank to look out but it was too late. J.L. had run him down. I saw that he was in pretty bad shape. Blood was running out of his ear and the skin was broken in three places. I helped Frank up but he was just about half knocked out.

Capt. Fisher was helping Capt. Brinkley with the line that Saturday. We got Frank to Capt. Fisher's truck and he stayed there the rest of the day. That night Frank said Capt. Fisher had told him if he wouldn't say anything about what happened to Capt. Floyd, he would see that he would get turned out as trusty. Frank asked me what I thought about it so I told Frank they are trying to cover up something. So Frank kept his mouth shut and in May of 1958 Frank got turned out on a highpower [made a convict guard, armed with a rifle] over the plow squad. I had got turned out do-pop [a half trusty] and was working at the horse barn. There was some long hours but not too much work.

Then one day about 12:30 o'clock a horse was running down the road behind the horse barn over across the bayou. It looked like old Smokey, J.L. Montgomery's horse. J.L. was the rider over the plow squad. Frank was the guard and there seems like there was another guard by the name of Ross with Frank.

I had heard a shot from a rifle but that was nothing to get upset about. I caught Smokey and there was a shirt on the saddle. Then in a few minutes I saw the plow squad coming in but there was just one trusty with about maybe eighteen men and that was Frank riding old Olphant Boy, the same horse J.L. had run over him in the Judy hole. Frank put his men on the yard and turned his .30-30 into a tower guard and went back to trusty barracks and lay down on his bunk and told Wiley Tolson, "I just killed a sorry S.O.B. and I am glad of it."

We went from the horse barn over to the yard and got the mules and brought them to the barn and unharnessed them and put them in the pasture. In just about 45 min. a deputy sheriff out of Pine Bluff, Ark., Jefferson County, came over there and made an investigation and Cap. Fisher went over at Two Camp where this happened and got J.L.'s body in the back of his pickup. He stopped at the horse barn and said, "Cooter, take that pair of mules and wagon over at Two Camp bridge and cover up the blood that J.L. lost."

So I got a shave and got over there and run the dogs off and covered it up. Then I went back to the barn and got the shirt that was on old Smokey. It was J.L.'s shirt and in the shirt pocket was a letter to Capt. Floyd. I opened the letter after about a week to see what was in it. The letter started out

> Capt. Floyd. I would like very much to talk to you because my life is in danger. If not mine some one else's life is. Me and Frank just can't make it here on this plow squad. There is bad blood between us if you will talk to me. Thank you J.L.

I just put the letter back in the shirt pocket and put the shirt inbetween the double walls of the saddle room since it was too late to do any good for J.L. Later on I went back to talk to Frank after he had been charged with first degree murder.

Frank said he couldn't get over that sorry S.O.B. running that horse over him. I asked Frank just what happened. He said that everybody was eating and the rank men was sitting down in a line or in two lines facing one another and he Frank had old Olphant Boy standing behind him but he had strayed off about twenty feet and when he went to get him he took a hame string [leather strap, part of a harness] and was slapping him across the nose with it and J.L. had told him to leave the horse alone. And that is what started the trouble. Frank said that "J.L. got his old .44 that he had tied to the saddle on old Smokey and I pulled the hammer back on my .30-30 and took aim on him. The men was between us. I shot one time and the bullet hit right in the middle of the men but it didn't hit any of them. They all layed down. And J.L. run

and got under Two Camp bridge. Then he asked me if he would lay his pistol on top of the bridge would I not kill him. I told him that I wouldn't. So he put the gun up on the bridge where I could see it. I told him to come out and he came out with his hands up over his head. I raised my rifle and let one drive. He fell and I didn't think he was dead so I walked up to him and kicked him to be sure he was. And he was. So then I did what I had to do next. I started my men in and Ross run off and left me. I started to kill that S.O.B. but I knew I was in enough trouble. So I just let him go."

It wasn't too long until Frank went to trial. He was tried in Jefferson County at Pine Bluff. And it looked like everyone in the plow squad was against Frank. There was enough. Frank got the electric chair. I think that Frank was the first man in the history of Arkansas to get the chair for the murder of another convict. If he wasn't I never heard of anyone else. I know that Frank had Capt. Wayne Henry against him. If it had been any other way it would have been life or 21 years. But it wasn't.

There was a lot of heat on one trusty fussing with another. Some of them even got ranked [demoted from trusty status back to regular inmate status]. Some of them asked to be ranked.

Capt. Floyd turned Russel Short and Tony Jones and two or three other men out. And some smart snitch told Albert Maples that they was going to take the long line and hit them [escape]. So Albert was the yard man and he took the old .45 sub Thompson and slipped down in the Warren field and layed in a thicket all day waiting for them to make the break. But it didn't come. When Tony and Russel found out about Albert laying and watching them they put their guns up and went back to the longline.

Then July finally came around and I got back in the hospital. I was getting some corn out of a crib and I jumped out of the crib with a sackful on my shoulder and I stepped on a corncob with my right foot and I layed my ankle flat on the ground. It took about thirty minutes to get to the hospital. The doc kept me that evening.

While I was there Capt. Brinkley brought a kid into the hospital. It looked like he would go maybe 180 pounds. And he had just come over from Cummins. The kid had got too hot and Capt. Brinkley had beat him until he passed out and he decided to bring him into the hospital and try to get the temperature down. But the doctor or what you might call him told Capt. Brinkley that he couldn't do him any good so Capt. Brinkley and two trusties drug him out to the truck and carried him over to the cold storage which was just across the gravel road. I watched them drag him out of the back of the truck and put him in the cold storage. Then Capt. Brinkley goes on back to the Judy hole to butcher up some more of the short hairs.

About 2 o'clock Dr. Scola from Cummins came over and came in the cell where I was. He said, "Son, what is your trouble?" I told him that I had turned my ankle. He looked at it and said, "That looks pretty bad." And told Sandy the doc to keep me there for a week or two. Then he ask if that was all he had to look at today. Sandy said, "Dr., Capt. Brinkley put one in the cold storage about thirty minutes ago." Dr. Scola said, "God damn him."

He left out of there on the run. His chauffeur got the wagon and went over to the cold storage. They put him in the back and out of there they went. We never seen that kid any more so I don't know just what happened to him. But Capt. Brinkley lost his job over that.

Thing began to get better after that. Capt. Brinkley was as sorry a man as you could find. He even looked sorry. He is so sorry that Hobart Williams has a bullet hole all the way through him. Brinkley was so damn lazy he didn't want to whip the boy. So he got Spike Patton to do it. But Hobart got up and started running and Bob Lee Watson put a .30 caliber bullet in him for no reason at all. But you didn't have to have a reason. Just being down here in this god forgotten hell hole called Arkansas State Prison. You was damn lucky to ever see the free side of life I can damn well tell you that. There was a lot of them that didn't you can count on that.

When I had a year done on that three I got a parole out of Tucker. I left there on Oct. 20th 1958. My mother and daddy came and got me. I think it was on a Monday evening. I wasn't out very long until I run up on one of my girl friends and we was married January 24, 1959. I lived my parole down. But I was right back in that hell hole again. I entered the Cummins unit on February 13th 1960. I just had a year. I think the charge was grand larceny. I copped out for one year anyway.

ENTERED ARKANSAS STATE PRISON
CUMMINS
FEBRUARY 13, 1960

Another sheriff carried me over this time. It was still run the same way. By the convict. The same convict as last time came up front and got me again. And back down that little narrow hallway to the barracks and we stopped at the yard desk. The yardman was all slicked up. He got my name and told me who he was. And on down to 4 barracks. They told the convict that was in charge of 4 barracks to put me on Punk Row. So I was just a little smarter than I was the first trip so I spoke up and I said, "I am a punk mobber. If you don't go for what I say just stick around a while and you can

damn sure find out." But I was laying it on just for the fun of it. I never did get in that bad a shape. Although I seen plenty of it go on and there was no "rape" in it.

On February 14, 1960, the yard man had me and some of the other short hairs up in 1 barracks cleaning it up a little. And a buddy of mine was brought back. He couldn't seem to keep his business straight on parole. Billy McCoy seen me in one barracks and he give the yard man something to let him in there with me. But I wasn't assigned to that barracks and didn't want to be. That was a hot barracks. There was more heat on men in there than there was on John Dillinger. But I got assigned up there and Billy McCoy too.

But I didn't stay but eight days before I was transferred back over at Tucker. I knew that I was going to Tucker. Just a few days before I was to go to court I and my wife paid Capt. Floyd Billings a visit. I told Capt. Floyd what was up and he said, "Cooter if you get any time you have your wife to call me just as soon as you get the time and tell me. And I will call and have them send you over just as soon as you get there." So she called him. And he told her that he would get me over there and he did. I believe it was on the 20th of February that I got over at Tucker. It was 2 o'clock in the morning when we got over there. We got a little sleep but not too much.

I was still a little shook up because this time I had a wife. And I was just a little worried about her. She was just 15 years old. But I knew that she was a good kid. But good people get messed up some times. But there was not much use in me worrying about that because there wasn't anything that I could do. I had asked her to try and stay with me. She promised that she would. And as far as I can say or could see she did. I guess every man that goes to any prison will ask his wife or girl if she can stay, and I just believe that every woman or girl friend will say yes. But I am sure that she did just what she told me she would do.

Capt. Floyd was off of the farm the Saturday that I got there. So the long line was working on the yard cleaning out some ditches for just something to do. So we was out of the building when on a Sunday night Capt. Floyd came over and called me up to the bars and talked to me for a while, then told Albert Maples the yard man to give me a jumper and overhalls and assign me back to the horse barn. So at 4 o'clock in the morning the night floorwalker woke us up and out to the barn we went. I knew all the things there was to do because I had worked out there about 9 months before. We had a different rider. This one was a bitch on wheels if I ever saw one. J.C. Sherman. He was about 5-1 in. tall, about 115 pounds and had a nose about 4 in. or it looked that long and would rat his momma off. I finally got him a little scared of me and we had no trouble.

197

Then one day Capt. Floyd sent for me to come up to his office. He said he had the D.A. on the phone and he wanted to know if I would take a year to run c.c. [concurrently] with the year that I was doing. If I did he could settle it right there so I told him that I would. That was the outcome of a little trip that one of my old buddys and me took. Got drunk and borrowed some money without asking anybody. It was a motel at Conway, Arkansas. Capt. Floyd called my sister and asked her if she would tell my wife and daddy if they would come up and get me and take me to Conway for the sentence. So they was there the next morning. And I went to Conway and got another year. The three months that I had already did was dead time. They say a man can't do dead time. Well in Arkansas you can do as much as the courts want you to do.

When I got back at Tucker Capt. Floyd put me back at the barn for three days. Then I was carried to Cummins on the second Sunday in May 1960 for a new number. I can't remember that one. But it was up in the 5000s. I had to stay overnight because I missed my ride with the Commissary truck that was going back to Tucker. That was because the yard man didn't understand the deal. Capt. Floyd called over and raised a little hell about it so they put me in a car going to Fort Smith and I got to Tucker on Monday evening

Capt. Floyd told me he had a new job for me if I thought I could handle it. He said he would talk to me about it in a few days. On a Sunday night Capt. Floyd asked me if I could handle a .30-30 rifle. I told him I was one of the best. And I thought I was. And still do. So I was put out with the plow squad. There was another guard by the name of Bill Clay. And I was back with the rider I was under the first time I worked at the horse barn. His name was Frank Ramsey. Frank was doing a life sentence for rape. But he was a fair guy. We had a good understanding between us. We had some good boys in the plow squad. But the water-boy had a little heat on him. He had tried to escape once while he was in the tractor squad. So he had been busted from do-pop to a rank man. They moved him off of the water cart and put him to plowing.

Any time they got out of their lines they had to get a wave from one of the guards or the rider. J.T. didn't do that. He got out and started toward a ditch and I yelled at him but he kept on going so I busted a cap. The bullet struck him in the leg, his left leg just above his knee. I knocked him down. The rider came up and asked what happened so we told him. Capt. T.R. Forest took him to the hospital and Capt. Floyd came over and ask what had happened so I told him. I told him I didn't have any more shells. I told him that I couldn't fire a warning shot because I just had the one shell. So Capt. Floyd went to the building and got me twenty rounds.

In about a week J.T. was out of the hospital and Capt. Floyd came down to the no. 2 well where I was guarding the plow squad and asked me if I would sign a accident report on the shooting so it wouldn't hurt the man when he went up for parole. I signed the report and when J.T. went up for parole he made it and got out. Everything looked like it was going to be smooth for a while.

Then along the first of July or the last of June we had put the plow squad on the yard for lunch. I was sitting beside the west tower trying to eat lunch and some of the longline had come in and the line guards was up above me in a shooter shack. It was John Crocker and Bob Dalton and Roscoe Marley. I heard a shot but couldn't tell just where it came from. So in a minute or two the yard man Stanley Green came running out of the building with a pistol. Then I knew something had went wrong so I dropped my tray down and run out in the road. Then Bob Dalton came out and Roscoe Marley came out but John Crocker didn't come out so then I had a damn good idea what had happened.

We all knew that John and Bob had been having trouble over a crap game in the barracks but I didn't think it was enough for anyone to get killed over. Roscoe said Bob stuck the end of the barrel up under John's chin and pulled the trigger. It was a sawed off 12 gauge shotgun and was loaded with 00 buckshot. It took the whole front of John's face off and a part of the top of his head.

When Capt. Fisher came over and got him they throwed him in the back of the truck like a damn dead dog. They put Bob back in the death cell for a while. When they took Bob to trial in Pine Bluff, Jefferson County, he was convicted and got a brand new 21 years. It might not have been so bad but John had already made parole and was just waiting for his release date to come around. It hadn't been but about a month since John's wife and little daughter had come to see him. John was from Texas. His wife was good looking and they had a pretty little girl. I think John's body was sent to a funeral home in Pine Bluff and John's wife came and claimed it.

Boy, the heat was on then. If a trusty was caught fussing with another trusty you could bet they wasn't a trusty any more. Then for about two weeks the shotgun guards had to carry their guns with the breech open. That way there couldn't be a accident. But that didn't last too long. The shooting started up again.

But I got off the plow squad and went to work as the night sheriff. It was a good job. I worked at night. I had to check the picket guards and feed them. There was two tower guards and the hospital guard and there was one down at the front gate. I checked them regular. They was some good men. A little young, but you could depend on them. I got just about anything that I wanted to eat on this job. And I was out by myself. I stayed on this job until I left the prison.

199

One Monday morning in October of -'60 I was coming in from the main gate and was at the back door of the mess-hall where the east tower is. I had given my .38 to the guard and was going over to see what was wrong with the guard in the west tower. I couldn't raise him. Stanley Green was supposed to be working that tower. He had been up all day on a Sunday because the trusties carried the rank men over for their visits when we went to work that Sunday night. I told Green and Tom Golding that I couldn't tell them to sleep but I wasn't going to check them until 2 o'clock. So I went over and got in the laundry and went to sleep. I woke up at 1:30 and got up and went by the hospital and woke Tom up and woke Green up over in the tower. He said he could make it now. I went and ate dinner or whatever it was at 2 o'clock in the morning and went down to the front gate. I took a cup of coffee with the gate guard and started back to the kitchen so I could let the barn crew and the dairy crew off. I had a six volt battery light, so I signalled the west tower but he didn't respond to it. So I tried again but still no response so I said to hell with it he has just gone back to sleep. By that time it was getting close to five o'clock. I went up to the east tower and asked Pokie if he could get a answer from Green with the spotlight. He tried but done no good. By this time the barn boys had brought the highpower horses out. I went over to see just what was going on. I pitched a rock up in the tower and couldn't get a answer. So when I turned to go back to the kitchen I put my light over in the horses and I spotted the stock of that damn big .30 cal. rifle. I didn't know what to do except get to hell out of there. And I did just that.

Capt. Floyd was coming across the bayou bridge and he seen me running across the yard and when he parked behind the messhall I was coming out the east tower. Capt. Floyd said what in the hell are you doing. I had a .30-30 carbine then. So I told him that Stanley Green was out of the west tower and had that .30 caliber rifle with him. Capt. Floyd said don't kill him if there is any way around it. Then Capt. Floyd said, "Cooter don't take any chances because Green is doing 10 years and has a holdover for armed robbery in Missouri and I think that carries a life sentence." Boy that shook me up good. It was still dark and nobody was going up on that .30.

By the time daylight had got there Green had left. But he left the rifle leaning up against the tower and that made me feel better. Because I knew that I was going to have to go on the hunt since he was one of my guards.

Grady Smart the dog sergeant came up with the bloodhounds. They wasn't much good to us though. The line rider and a few more trusties went out after him but he was not armed so there wasn't too much to worry about. Herman Wool had already said that if he could find him he was going to blow his goddamn head off. Because Smart wanted to make the parole board. He was to go up on the next board.

200

He had ten ten-year sentences in the beginning but got all of them run into one and had been there quite a spell. So I kind of believed what he said and I knew that Green was not armed and was helpless.

We hunted him from about five o'clock until 11 o'clock that morning. Everybody had give up except me and Herman Wool and Grady Smart. Herman was up in front of me and Grady Smart was out in a field. When I came across a road ditch the little willows lapped together and made it hard to see up the ditch, but I bent over and saw a pair of work shoes. They had a notch cut out of the heel. I knew that I had found Green. He was asleep. I believe if Herman hadn't of made the statement that he had I wouldn't have woke him up. That was the hardest thing I ever did. Because I knew what was going to happen. But I got down there with him. I got him awake and asked him if he was ready to go. He said he was. I shook him down. But I knew he didn't have anything so I told him to stay close to me. I fired 2 fast shots. That is a escape shot. Herman and Grady came running after him, but they didn't get him. I put him in the back of the pickup and we went to Capt. Floyd's office.

He slapped him around a little but he didn't get the hide. Stanley had told me before we got in that he wasn't trying to get away. He was just trying to get more time so they [Missouri authorities] would drop that hold over on him. So I told him that he had damn sure done the right damn thing to get more time.

The state hadn't tried him when I got out on Dec. 9, 1960. I left on a Saturday morning. It was raining and cold as hell. My wife and my daddy and sister came over and got me. They was a little late so Capt. Floyd ask me if I had any money. I told him that I had 3 or 4 dollars. He said, "If you want to borrow ten you can get it and send it back or bring it to me." Then the office boy said that my wife was coming through the gate. I said that I never would come back to that damn hole.

But things didn't work out that way.

I used to go over to Tucker and visit when I got ready. Capt. Floyd told me that I could get in just any time I want to. In June of 1961 I had a wreck and lost my left arm. The state police had pulled my driver's license and had stuck two or three charges on me. So I had my wife call Capt. Floyd and see if he could come to the hospital. He did. And ask me what he could do to help me. I told him what had happened and he said that they would drop all the charges against me and give me my license back to me. That evening they did just that.

Then all this crap came out on Capt. Floyd about the [Tucker] telephone. I would have to see it happen before I could believe any of it. I know that the hide was there. I seen it and I also got it. But that other crap was being used by the cons I believe. I can just say one thing. I believe Capt. Floyd was a good man. He treated me like a son.

201

But I never did lie to him. He never did ask me to rat a man off. I guess he knew who to ask and who not to ask. Capt. Floyd must have did a lot of changing from 1962 up until 1967 but I didn't see him after 1962 until I seen him in Little Rock on TV when he was coming out of the courthouse after his trial. Where he got a suspended sentence.

ACKNOWLEDGMENTS

None of my work at Cummins would have been possible without the free access provided to me during the four years of my visits by Commissioner Terrill Don Hutto and his staff, and the trust and help given me during those visits by Cummins inmates. I was grateful to them all more than three decades ago, and I remain grateful now.

I want to especially thank Cooter—Charles Hackney—for entrusting to me his astonishing memoir.

The Michael Disfarmer photographs are from the collection of Michael Mattis. My thanks to him and Hava Gurevich for their generous assistance.

Thanks also to—

The John Simon Guggenheim Foundation. My first and second visits to Cummins took place on the way to and back home from a year in San Francisco as a Guggenheim Fellow.

University at Buffalo, for the Samuel L. Capen Chair in American Culture, grants for prison research and documentary photography from the Baldy Center for Law and Society and a publication subvention grant from the College of Arts and Sciences.

Janet Francendese, editor in chief of Temple University Press, for her wise counsel and continuing friendship.

Jean Malaurie, Doug Harper, Mark Maio, Tom Rankin, Bill Ferris, Alex Bitterman, Bill Christenberry, Dianne Hagaman, and Howie Becker for the ongoing conversation about looking at things and the work of the eye.

Nina Freudenheim, who gave some of these images their first public showing at her Buffalo gallery.

And, as always, Diane Christian, who read the text in every stage and looked at the prints in every iteration, and who understood what this was all about from the beginning.

Bruce Jackson is SUNY Distinguished Professor and Samuel P. Capen Professor of American Culture, University at Buffalo. He is the author of more than 20 other books, including *The Story Is True: The Art and Meaning of Telling Stories* (Temple), as well as a documentary filmmaker and photographer. The French government named him Chevalier in L'Ordre des Arts et des Lettres, France's highest honor in the arts and humanities.

Alex Bitterman is Assistant Professor in the School of Design at Rochester Institute of Technology. He is the author of several books including *Design Survey: a workbook introduction to the design professions* (Pearson Custom) and is the founding editor of *Multi: The Journal of Diversity and Plurality in Design*, an international journal of design practice and pedagogy.

This book was typeset by Alex Bitterman in Garamond Premier Pro with titles in Futura. It was printed on 128gsm GoldEast Matte by Everbest Printing Company of Hong Kong/China, which also prepared the printing plates from Bruce Jackson's digital image files. The duotones were printed with PMS Black C and PMS 607 inks.

Jeannine McKnight edited the manuscript and read the typeset proofs.

Charles Ault supervised the production and printing of the book.